The Digital Eye

THE DIGITAL EYE

Photographic Art in

Sylvia Wolf

the Electronic Age

Prestel MUNICH · BERLIN · LONDON · NEW YORK

Henry Art Gallery UNIVERSITY OF WASHINGTON · SEATTLE

Front cover: Wendy McMurdo, *Helen, Backstage, Merlin Theatre (The Glance)*, 1995. Laserchrome print, dimensions variable · **pp. 6–7:** Paul Thorel, *Magma*, 2002. Digital print on alfa cellulose based paper, 26 1/8 x 39 3/8 in. (66.5 x 100 cm) · **pp. 8–9:** Luis Gispert, *You're My Favorite Kind of American*, 2008. From the series *You're My Favorite Kind of American*. Chromogenic color print, 72 x 110 in. (182.8 x 279.4 cm) · **pp. 10–11:** Aziz + Cucher, *Burnt Mountain*, 2007. Chromogenic color print on Endura metallic paper, 50 x 72 in. (127 x 182.88 cm) · **pp. 12–13:** Chris Jordan, *Plastic Bottles*, 2007. Pigmented inkjet print, 60 x 120 in. (152.4 x 304.8 cm). See p. 35 for detail. · **pp. 14–15:** Siebren Versteeg, *100 Years of Google Images*, 2007. Pigmented inkjet print mounted to aluminum, 22 5/8 x 51 1/8 in. (57.5 x 129.9 cm) · **pp. 16–17:** Daniel Canogar, *Gravedad Cero 2*, 2002. Cibachrome print, 47 x 66 in. (119.5 x 167.5 cm) · **pp. 18–19:** Jon Haddock, *Time Inc. v. Bernard Geis Associates, 293 F.Supp.130 (S.D.N.Y. 1968)*, 2003. Digital image, dimensions variable · **pp. 20–21:** Sean Dack, *Unmarked CIA Airplane*, 2008. Chromogenic color print, 30 x 44 5/8 in. (76.2 x 113.35 cm) · **p. 168:** Isaac Layman, *Cabinet* (detail), 2009. Chromogenic color print, 72 x 79 in. (182.8 x 200.6 cm) · **Back cover:** Mariko Mori, *Esoteric Cosmos: Pure Land*, 1996–98. Glass with photo interlayer, 120 1/8 x 240 1/8 x 7/8 in. (305 x 610 x 2.2 cm) · **Endpapers:** Daniel Canogar, *Horror Vacui*, 1999. Digital wallpaper, dimensions variable

Produced in cooperation with the Henry Art Gallery:

HENRY ART GALLERY

University of Washington, Box 351410, Seattle, WA 98195

www.henryart.org

© PRESTEL VERLAG, MUNICH · BERLIN · LONDON · NEW YORK 2010

for the text, © by Sylvia Wolf, 2010

for illustrations of works of art, © by the artists, 2010

with the exception of pp. 92, 93: © Andreas Gursky / courtesy Monika Sprüth / Philomene Magers / VG Bild-Kunst, Bonn; pp. 114, 115: © Loretta Lux / VG Bild-Kunst, Bonn; and pp. 146, 147: © Thomas Ruff / VG Bild-Kunst, Bonn

Prestel, a member of Verlagsgruppe Random House GmbH

PRESTEL VERLAG

Königinstrasse 9 · 80539 Munich · Tel. +49 (0)89 24 29 08-300 · Fax +49 (0)89 24 29 08-335

PRESTEL PUBLISHING LTD.

4 Bloomsbury Place · London WC1A 2QA · Tel. +44 (0)20 7323-5004 · Fax +44 (0)20 7636-8004

PRESTEL PUBLISHING

900 Broadway, Suite 603 · New York, NY 10003 · Tel. +1 (212) 995-2720 · Fax +1 (212) 995-2733

www.prestel.com

Prestel books are available worldwide. Please contact your nearest bookseller or one of the above addresses for information concerning your local distributor.

Library of Congress Control Number: 2009942589

British Library Cataloguing-in-Publication Data: a catalogue record for this book is available from the British Library.

The Deutsche Bibliothek holds a record of this publication in the Deutsche Nationalbibliografie; detailed bibliographical data can be found under: http://dnb.ddb.de

Editorial direction by Christopher Lyon · Editorial assistance by Ryan Newbanks · Picture research by Gina Glascock-Broze, Seattle · Cover and interior design by Mark Melnick, New York · Production at Prestel by Nele Krüger · Origination by Reproline Mediateam, Munich · Printed and bound by C&C Printing

Verlagsgruppe Random House FSC-DEU-0100

The FSC-certified paper Chinese Golden Sun matt art is produced by mill Yanzhou Tianzhang Paper Industry Co., Ltd., Shandong, PRC. Printed in China

ISBN 978-3-7913-4318-1

Contents

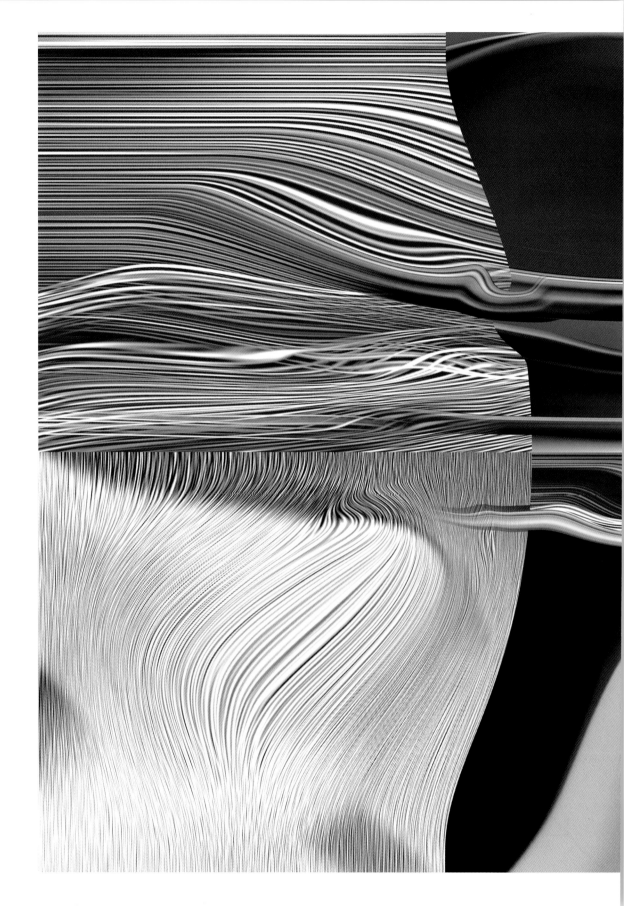

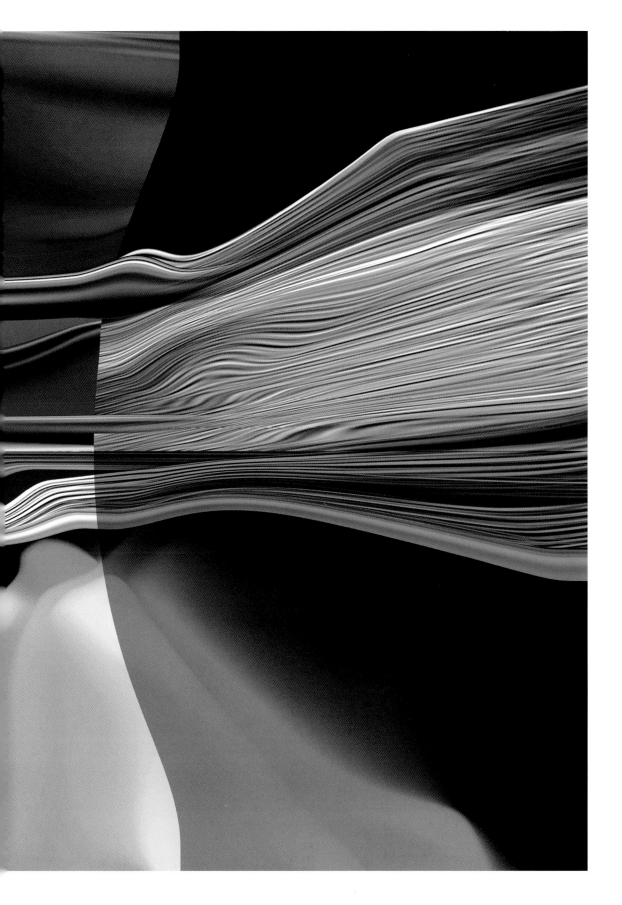

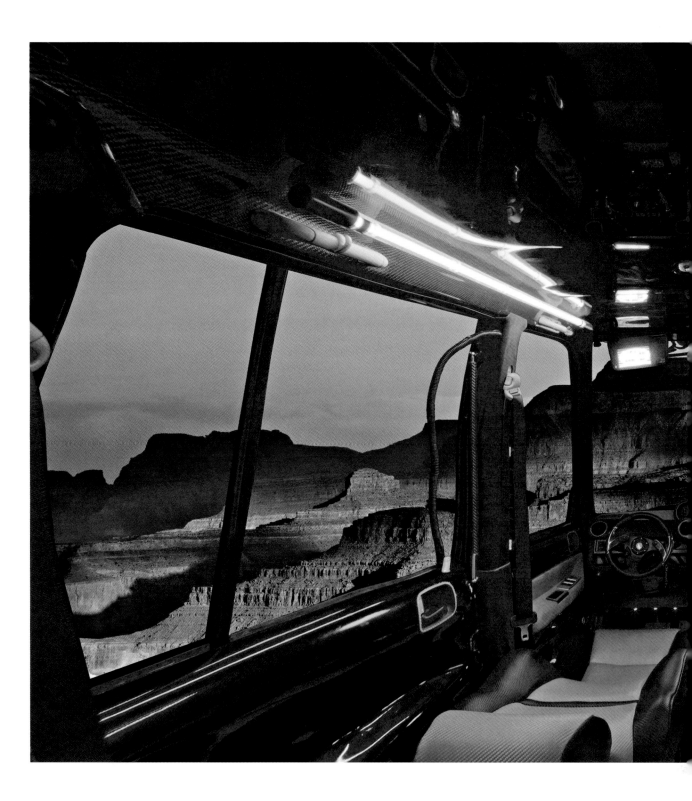

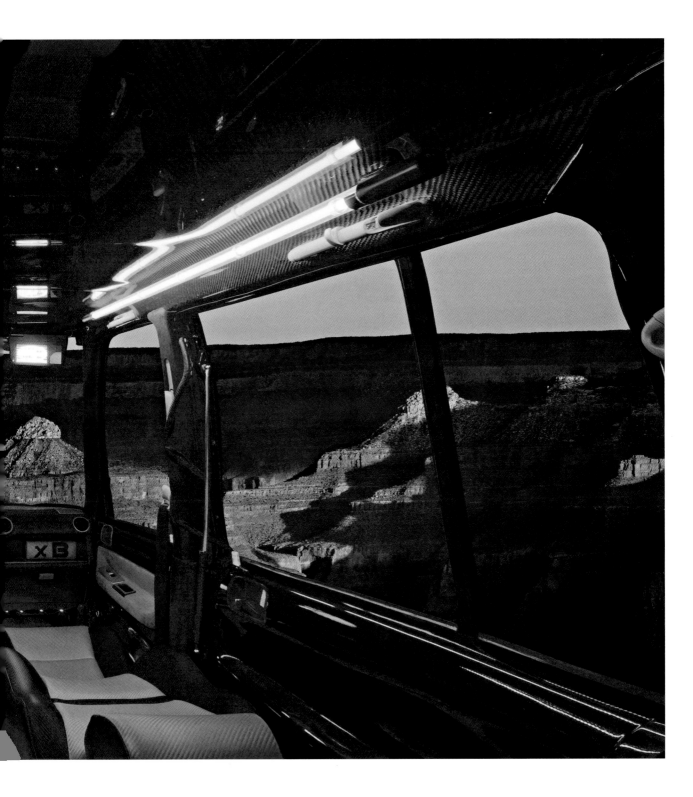

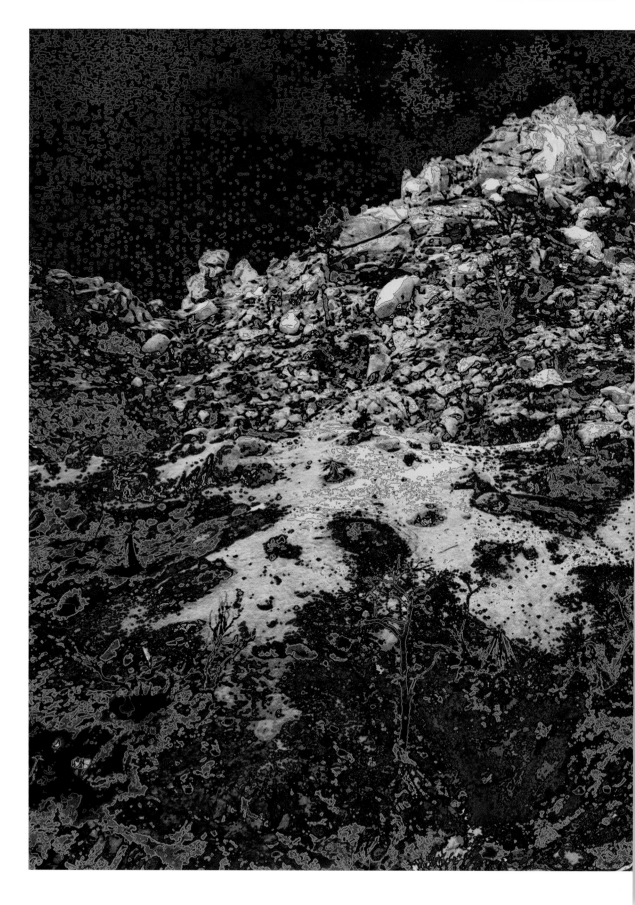

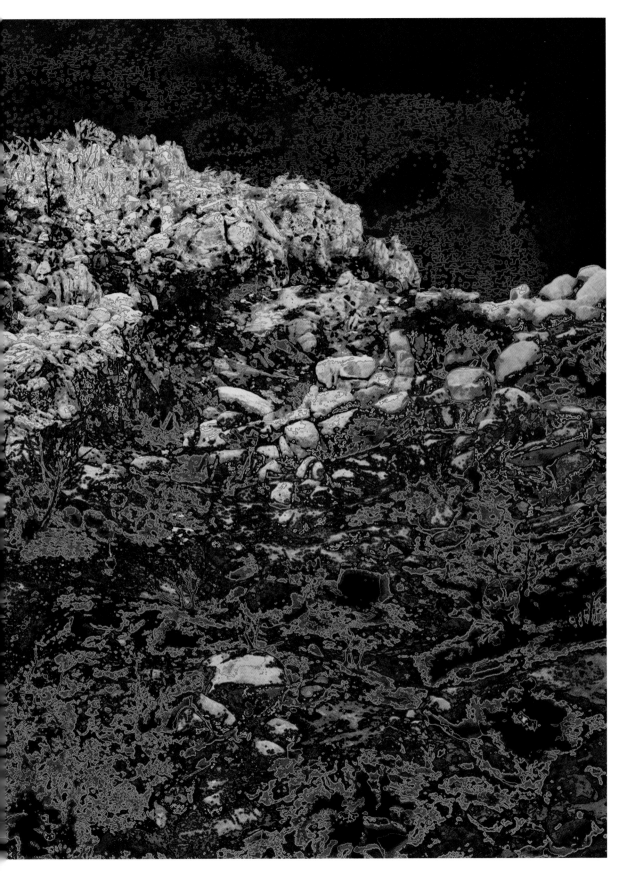

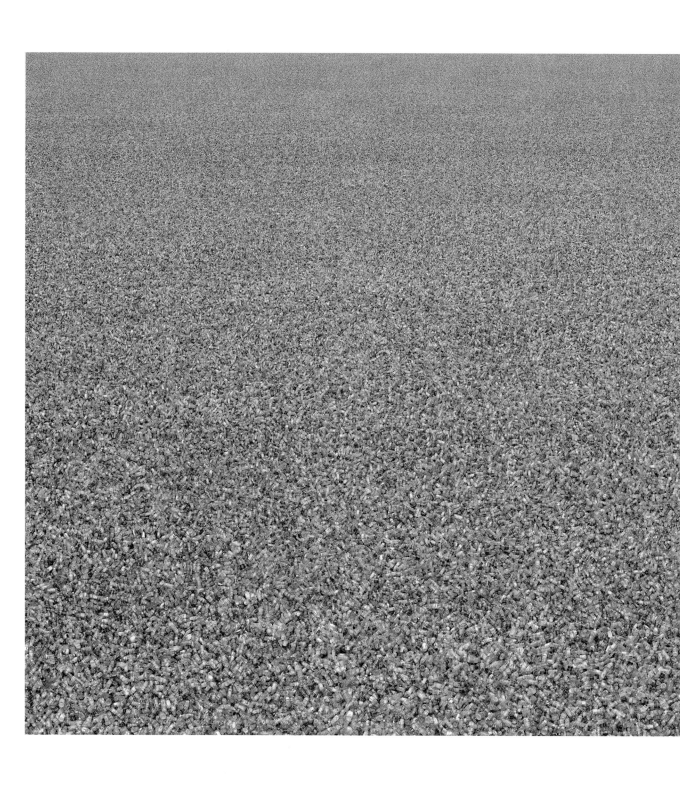

```
38  125 202 183 155 142 175 165 102 97  164 195 170 163 168 162 158 161 167 167 169 166 163 166 176 120 44  101 139 186
28  110 182 175 158 144 168 152 83  69  128 161 152 153 161 160 161 164 188 188 172 171 169 173 179 113 26  71  98  135
40  126 203 185 164 150 171 158 98  89  149 181 161 151 155 150 153 156 160 160 161 160 165 173 115 38  92  127 171
95  53  144 169 163 112 163 113 13  47  144 191 183 164 164 163 161 160 161 163 165 165 165 168 169 75  43  79  77  100
86  43  134 166 159 107 161 107 1   20  107 155 155 156 162 164 165 163 162 164 166 167 166 63  21  49  45  64
100 55  153 177 164 113 165 111 9   37  134 181 173 155 151 154 159 156 154 156 157 158 159 162 166 70  37  73  73  93
74  45  111 160 103 87  102 61  10  76  201 227 203 167 166 168 167 169 170 170 169 169 189 168 167 112 22  79  150 167 91
69  35  105 159 97  56  97  56  0   45  156 189 174 170 160 161 166 167 169 172 173 172 169 168 111 12  52  108 130 67
76  45  121 169 104 68  105 60  4   67  189 213 191 160 154 155 162 163 162 163 162 162 183 166 114 22  73  138 157 88
38  29  78  160 108 44  28  40  31  105 200 208 188 150 152 155 154 165 168 167 166 171 172 177 116 38  101 169 178 80
34  20  73  162 110 40  24  34  15  68  151 167 161 145 147 145 149 162 166 166 167 172 176 181 115 33  81  133 144 55
41  29  87  178 124 56  34  42  28  95  186 196 181 152 154 153 154 162 160 159 158 162 167 175 118 47  106 166 172 72
162 99  144 185 180 142 134 145 96  121 197 217 204 134 142 157 151 156 151 148 145 148 155 153 123 140 178 196 135 55
151 91  136 179 174 140 138 147 90  94  153 174 173 126 141 155 150 157 152 149 148 150 157 154 123 139 172 182 120 31
170 109 152 194 187 155 155 166 100 119 186 205 200 147 163 178 167 188 157 152 152 152 159 135 160 195 203 137 52
128 108 119 108 62  78  149 149 147 197 235 220 195 129 108 132 123 129 136 126 109 105 115 112 71  147 193 221 203 141
117 100 111 102 52  68  146 149 142 181 208 188 167 119 108 135 130 140 147 139 130 129 124 108 68  141 180 199 179 107
134 118 127 115 62  80  161 161 164 202 227 207 190 142 128 158 153 163 172 166 159 164 131 87  162 203 220 199 141
89  108 98  87  33  14  52  60  63  137 214 224 191 160 168 166 128 142 148 144 149 134 112 151 63  95  158 215 225 201
78  100 95  85  29  5   42  54  50  109 179 188 160 136 156 163 134 153 181 164 181 160 105 126 47  75  128 176 191 170
95  120 112 101 41  11  50  63  64  129 198 207 184 163 178 182 156 179 188 188 202 182 134 154 61  94  151 203 220 206
53  83  137 128 54  5   4   3   1   22  118 197 207 235 238 228 164 152 121 121 189 133 89  154 72  84  115 192 215 219
45  79  138 129 51  0   0   0   0   7   87  161 165 189 201 214 163 155 133 135 205 141 66  118 48  54  77  142 166 179
57  94  155 147 64  7   3   3   0   17  111 186 191 214 222 231 179 174 153 159 224 158 94  154 68  74  105 181 204 218
54  61  58  27  14  8   6   4   38  36  42  105 105 168 144 148 99  68  33  38  115 93  88  181 77  72  115 197 179 145
46  54  52  20  5   1   0   0   33  34  32  84  68  124 105 124 89  59  33  43  122 91  61  143 48  41  78  146 132 110
56  65  61  24  9   6   4   2   39  42  42  103 94  148 124 139 100 71  45  60  143 110 87  181 72  63  107 189 169 144
11  3   5   1   4   10  7   6   31  68  29  34  92  101 50  59  20  13  20  25  98  85  100 174 73  66  79  185 148 69
4   0   0   0   0   5   5   0   20  59  29  33  88  93  44  59  27  22  37  48  123 91  73  139 51  45  48  142 119 53
11  3   8   1   1   9   4   0   27  71  37  46  107 111 60  71  40  40  58  74  148 113 103 172 69  66  73  172 144 74
63  63  54  35  28  36  9   0   2   10  52  89  145 98  144 214 155 64  53  49  58  87  171 114 26  77  109 66  45  87
63  66  59  39  31  39  10  0   0   5   50  84  146 98  136 212 162 88  85  82  82  81  134 82  16  76  103 48  36  94
77  81  75  55  45  49  18  4   3   13  61  100 164 117 158 228 180 114 118 114 107 108 171 107 22  87  120 65  48  111
39  65  78  91  92  88  81  71  60  51  45  101 96  89  210 242 235 130 35  23  15  73  105 27  8   14  66  98  117 134
31  60  73  86  91  89  84  73  64  55  46  103 83  190 215 220 135 47  31  15  55  78  13  1   8   49  92  105 151
38  71  85  101 106 107 101 90  81  71  65  123 114 102 212 228 232 151 86  44  25  73  102 24  4   15  76  110 130 175
6   5   0   7   11  14  21  31  46  70  65  50  85  128 206 236 239 185 41  6   21  32  8   8   9   3   11  126 199 179
0   0   0   1   4   11  22  38  53  64  63  58  94  126 186 206 216 180 47  2   2   13  0   1   0   0   104 177 161
1   0   2   7   11  18  29  45  61  76  78  75  115 148 209 220 195 60  9   12  23  4   5   7   2   7   124 203 186
7   4   4   3   11  4   3   2   5   6   4   9   40  80  122 147 163 148 79  59  72  69  22  12  3   7   47  68  131 150
1   0   0   0   0   3   1   0   0   0   5   38  77  109 131 148 148 89  65  69  61  21  13  2   8   47  70  136 154
5   4   3   1   2   2   1   0   1   1   2   9   47  92  127 149 168 167 110 84  89  82  34  25  12  16  61  90  158 173
9   13  10  19  16  9   6   7   7   8   8   7   2   6   18  24  33  37  52  75  88  103 99  98  89  66  80  76  88  124
3   7   5   13  10  3   0   2   2   0   0   1   7   16  22  30  46  73  91  109 110 111 96  82  116 113 126 167
7   11  10  18  15  8   4   6   5   6   6   3   0   7   14  22  31  38  58  85  105 129 130 129 118 107 141 143 156 167
12  19  17  24  15  10  13  10  13  10  9   7   9   8   7   6   4   4   8   8   16  19  26  39  46  49  46  50  62
6   11  9   17  9   4   7   4   5   8   4   0   0   0   0   0   0   0   0   0   0   0   11  19  32  45  56  63  76  90
10  16  16  24  16  9   12  8   8   12  7   4   4   7   3   1   0   0   0   0   0   0   17  27  43  58  71  80  96  111
3   11  19  12  16  33  37  24  11  10  13  20  8   8   7   6   6   5   6   6   4   13  46  30  52  30  1   0   0   0
0   4   10  5   11  29  32  17  3   4   5   10  17  6   5   3   1   0   3   3   2   0   7   36  24  51  27  0   0   0
3   7   15  9   17  39  41  22  8   9   5   10  17  6   5   1   3   2   3   4   2   14  47  34  61  34  0   0   0
25  6   6   7   16  62  36  9   14  76  50  29  10  9   9   4   9   7   6   9   22  31  112 57  2   7   5   12
23  0   0   0   8   53  31  3   8   70  43  20  4   4   3   1   0   1   0   3   15  25  107 52  0   2   0   15
33  3   0   0   13  64  40  10  15  77  50  28  8   7   5   4   10  23  34  118 59  1   2   0   15
76  47  18  4   6   13  15  6   6   35  43  14  9   8   12  12  9   7   7   10  8   6   1   4   15  13  8   10  9   17
84  51  17  1   1   5   8   2   3   29  36  5   3   2   6   6   3   2   1   4   2   0   0   5   3   0   4   3   12
99  64  25  3   5   10  11  4   6   35  43  11  7   7   5   8   9   7   5   5   6   3   0   1   11  10  3   6   6   17
54  64  81  50  11  6   7   5   7   9   8   9   9   9   10  12  17  11  7   7   8   6   7   7   5   6   7
63  65  76  45  7   1   0   0   0   0   0   1   0   1   1   2   8   8   13  8   6   5   4   1   0   1   0   2   3
78  77  92  56  12  4   3   3   3   0   2   4   5   4   5   6   6   8   13  8   6   5   7   11  12  8   7   5   5   5
28  12  17  30  16  9   8   7   9   11  11  9   9   0   9   8   8   9   11  10  6   7   11  12  8   7   7   5   5   5
26  5   8   23  10  3   2   1   2   1   9   9   0   8   1   3   8   8   6   5   5   5   10  10  7   6   6   5   5
34  9   13  29  16  9   7   5   6   4   4   3   5   5   5   5   6   8   6   5   5   10  10  7   6   6   5   5
23  10  9   11  10  8   11  10  10  10  11  11  7   6   6   8   5   5   10  7   7   6   6   5   5
15  0   1   3   3   8   5   3   1   1   1   7   5   5   5   1   0   0   5   0   5   5   4   4   4   4
26  9   5   4   8   8   9   7   4   4   5   7   5   5   6   1   0   0   5   0   4   5   4   4   5   6
18  10  12  13  13  14  13  11  10  11  10  11  11  12  8   8   8   7   8   7   5   9   6   7   6   7   6   6
11  4   4   2   3   6   4   3   1   2   2   1   1   1   7   8   4   3   2   5   4   3   2   5   4   4
16  8   10  9   8   9   8   7   5   4   4   4   6   6   8   5   5   4   6   4   3   2   6   4   4   6
9   10  13  12  13  15  13  10  10  11  11  10  11  12  11  6   9   11  8   11  9   7   10  10  8   6   6   5   6
4   4   5   3   3   5   4   1   4   2   1   2   1   2   1   1   1   1   1   2   2   1   3   2   3
9   7   9   8   9   9   7   4   4   5   6   7   7   5   6   7   4   4   5   2   4   2   1   2   2   2   4
8   7   8   8   14  12  8   9   10  10  10  9   9   8   8   8   8   10  10  8   6   6   6   6   5   5
2   1   1   8   1   7   5   0   1   1   0   0   1   3   3   1   2   1   7   10  8   3   1   2   2   2   1   3
7   5   5   6   11  8   3   3   4   3   3   4   6   6   5   5   7   8   3   4   4   5   3   2   2   2   2   2
7   1   1   0   1   9   4   8   6   2   2   1   3   6   8   8   8   7   9   9   3   7   6   6   6   5   5   5
1   1   0   1   8   6   2   2   2   3   4   5   4   5   4   7   1   5   0   0   0   1
6   4   3   5   8   8   6   2   2   3   2   1   6   4   6   6   6   6   0   0   2   4   3
6   0   2   0   2   1   1   2   0   0   0   1   2   0   0   2   1   1   0   0   0   1
4   1   2   1   1   1   2   1   0   0   1   2   2   2   4   4   5   5   0   1   1   1   1   4
6   8   1   6   8   6   6   4   4   4   4   5   4   5   5   5   5   4   6   4   4   7   10  9
0   2   1   2   2   1   2   1   0   1   2   1   3   4   3   1   1   0   1   1   1   4
4   6   5   5   4   4   2   1   2   6   1   1   1   3   2   3   4   4   3   2   2   3   4
8   7   9   9   8   8   7   8   6   5   6   5   4   5   4   5   3   4   6   5   4   6   11
8   2   1   2   3   1   1   1   0   1   3   1   1   2   2   2   2   1   3   1   1   1   3
5   5   5   6   6   7   5   5   4   3   2   1   2   3   1   5   1   1   1   1   2   4
7   7   9   9   8   7   8   9   14  11  11  8   6   3   5   4   6   6   1   5   4   5   4   2
1   0   0   3   2   1   5   6   10  7   5   7   7   4   3   4   3   3   3   1   0   0   3
3   3   3   3   4   5   6   5   10  7   5   4   4   7   3   3   2   2   1   2   1   1   5
5   5   5   0   0   6   1   1   5   2   1   4   4   7   4   3   3   8   6   4   4   6   5
2   1   1   1   0   0   0   0   1   0   1   2   2   3   4   5   4   3   2   1   2   2   1   5
5   4   1   3   2   2   2   2   3   2   2   2   3   5   6   3   8   7   5   1   2   1   0   0
5   0   0   0   0   0   0   0   0   0   1   1   1   4   4   5   3   2   1   1   1   0
2   1   1   1   0   1   0   0   1   3   1   0   1   2   0   1   1   2   0   0
6   7   7   7   4   1   0   0   1   1   1   3   1   2   2   7   6   4   4   5   6   8
1   3   4   3   0   0   1   1   1   1   1   0   0   0   3   2   2   1   1   2   2   6
3   4   4   2   1   1   1   2   1   1   1   0   1   3   3   2   3   2   3   4   5
13  13  9   7   6   4   5   5   3   2   4   4   3   4   3   3   4   4   5   6   8
7   7   5   8   4   3   1   2   1   1   1   1   0   1   1   0   0   0   1   1   6
11  11  7   4   5   5   3   2   1   1   1   1   0   1   1   0   0   1   1   2   5
20  19  16  16  18  14  12  13  9   8   5   3   3   3   3   2   4   0   0   0
16  15  14  16  13  9   8   5   3   3   2   2   2   1   2   1   1   0   1   0
23  21  17  19  16  11  10  6   4   4   3   3   3   1   2   1   1   2   1   2
26  27  25  25  24  20  20  18  15  12  12  10  10  10  8   8   6   5   4   4   3   2   2   2   2   1
28  28  27  27  22  20  17  16  13  10  8   7   7   8   6   5   5   4   3   0   1   1   1   1
37  36  31  34  34  24  22  20  17  14  13  12  7   8   6   5   5   3   1   3   1   1   1   1
33  29  25  34  29  25  25  27  22  18  18  18  17  21  18  13  12  13  10  7   7   3   4   3   4
36  32  32  34  32  26  25  28  22  17  17  17  14  18  14  12  11  11  7   3   6   4   1   1   1
52  46  44  48  42  32  32  33  27  22  22  21  18  23  19  14  13  13  8   5   5   4   1   1   1
137 118 103 80  50  30  27  24  21  19  22  25  24  28  24  21  19  18  16  14  14  14  7   4   1   9   11  10  7
134 118 105 82  53  34  31  27  27  24  19  22  24  24  24  20  19  17  17  15  13  10  9   4   5   14  11  8
151 135 121 101 71  48  45  40  33  24  28  30  30  25  25  23  20  17  15  15  10  6   5   15  15  12  9
224 222 216 208 183 150 136 116 105 73  46  47  42  39  33  35  39  22  22  27  28  17  15  14  13  13  10
197 198 196 193 173 142 130 110 100 71  44  47  43  39  32  32  36  19  20  22  23  20  18  14  11  11  10  9
207 208 207 207 191 161 149 129 116 85  57  59  57  52  42  39  42  26  26  30  30  17  17  13  12  11  9
176 178 181 182 179 178 179 174 175 156 136 123 97  78  57  51  51  45  43  34  34  30  34  32  30  25  26  23  21  16  15
152 153 152 151 156 154 154 154 160 142 124 126 118 97  77  57  51  51  43  32  32  29  34  24  25  21  19  16  15
162 163 160 162 166 165 164 164 165 155 137 138 131 109 87  62  56  56  49  39  35  38  36  29  30  24  22  19  16
```

```
73  171 172 172 169 168 174 176 174 165 183 195 170 162 165 161 167 173 175 171 172 173 172 173 171 172 174 180 180 181
71  171 171 170 167 168 176 181 181 176 191 202 180 173 179 177 179 184 183 176 179 179 176 177 176 178 180 186 187 187
70  170 168 166 161 163 177 186 187 181 199 210 189 184 191 196 186 191 196 185 179 173 175 177 178 178 179 182 182 182
70  171 171 164 154 152 162 184 188 183 172 178 159 154 157 159 161 172 190 185 166 177 190 205 208 211 211 217 219 218
74  174 169 158 157 173 178 196 198 179 186 190 176 175 179 178 174 176 181 179 175 185 199 206 208 209 209 215 216 215
68  175 178 173 164 165 182 206 209 192 202 200 186 184 190 191 189 192 201 196 182 189 207 215 219 219 218 222 223 222
55  191 178 147 148 155 176 211 248 215 165 168 175 181 189 201 211 228 231 235 187 183 199 180 181 241 240 239 238 237 237
99  198 188 159 162 167 176 177 172 174 174 177 194 201 206 214 222 227 183 180 232 229 229 229 228 227 227 228
82  211 201 176 178 183 191 188 179 180 179 179 187 190 197 200 233 190 194 240 236 236 236 235 235 235
26  193 174 162 164 169 111 101 144 155 176 204 219 232 235 235 234 230 236 242 196 146 191 196 181 168 152 139 134 134
51  202 182 170 170 169 106 90  133 149 173 204 214 221 225 227 225 221 226 231 202 175 193 197 184 173 162 152 153 153
77  214 184 173 171 169 112 102 148 160 180 211 223 230 232 230 230 228 234 239 213 172 210 213 200 189 182 175 174 174
47  167 163 166 158 120 38  101 177 168 183 240 241 240 233 222 210 190 175 152 117 85  74  62  53  43  42  40  31  33
66  174 167 165 156 116 23  79  154 146 163 223 225 222 221 215 201 187 164 136 103 92  82  71  64  65  65  63  65
30  179 165 163 157 121 35  98  177 171 187 235 234 230 229 226 223 213 199 178 152 123 115 105 93  86  94  99  94  97
54  148 118 92  95  68  20  63  161 199 180 226 238 244 233 184 122 80  49  34  26  24  21  23  23  24  43  52  39  43
75  160 124 88  85  57  11  47  134 173 153 206 222 226 223 186 132 92  64  53  49  42  39  41  40  43  71  84  73  82
97  177 141 101 98  69  19  64  162 201 180 223 231 230 193 144 108 82  72  68  62  61  64  63  69  100 115 101 110
0   92  110 129 118 49  30  118 216 221 151 156 213 230 146 56  28  21  26  30  32  29  32  31  25  37  116 112 72  74
5   113 129 142 123 46  14  85  178 185 151 202 212 134 52  31  29  34  47  53  52  59  57  51  64  143 149 118 126
8   139 157 162 137 54  26  113 208 211 151 170 220 222 144 60  40  41  50  65  74  76  87  84  79  91  168 154 145 153
2   79  114 110 114 56  60  103 129 95  94  114 134 110 22  15  20  25  26  29  36  39  50  64  98  73  63  66  105 175 131 74  64
4   90  128 122 123 50  34  70  93  60  83  136 161 115 21  17  26  32  39  50  64  98  53  113 117 151 211 177 126 117
4   113 151 142 141 65  50  94  116 82  104 161 188 132 26  23  37  46  57  71  86  57  71  125 152 141 148 177 225 196 155 147
9   111 106 92  130 67  63  72  56  71  154 133 84  87  32  23  38  54  45  58  62  55  73  92  94  122 146 104 60  55
0   117 107 78  112 43  31  44  31  43  136 153 137 123 39  23  39  49  99  96  121 146 152 74  190 155 113 108
7   140 126 104 139 61  52  64  48  66  165 184 167 147 57  37  67  91  96  118 124 124 150 174 180 195 206 176 143 139
6   110 81  114 213 188 118 79  54  127 222 167 124 100 67  46  82  115 76  46  31  22  42  63  88  142 123 89  89  99
2   119 71  72  154 137 82  48  24  86  182 159 157 97  74  116 148 105 73  60  58  80  105 134 176 159 130 139 150
4   142 86  104 205 181 109 68  44  117 223 187 185 171 121 95  140 173 130 96  82  108 135 164 201 188 161 167 174
2   107 47  77  172 177 118 46  35  84  146 143 143 101 70  67  82  71  35  18  21  35  37  98  191 154 101 109 117
2   113 34  40  122 128 80  20  10  82  114 130 174 143 110 93  105 95  57  37  39  50  67  70  137 209 177 139 152 171
8   138 53  67  161 162 104 38  25  74  145 151 198 175 142 73  120 130 120 80  59  61  74  95  99  164 228 202 171 182 191
8   146 103 48  30  23  10  46  61  78  45  35  124 122 77  84  78  47  28  14  12  16  20  61  166 177 99  88  88
4   154 103 35  15  8   0   42  63  82  48  41  143 164 120 104 96  84  63  44  29  30  36  43  90  182 197 133 129 134
4   176 117 47  28  17  4   53  82  103 69  59  168 196 147 133 114 86  63  47  51  59  68  71  116 200 215 157 157 163
1   124 59  13  2   2   2   27  96  114 47  15  101 196 118 102 48  13  9   13  14  17  20  13  78  142 121 68  124 85
4   119 52  6   0   0   0   23  101 129 49  16  96  209 150 137 75  29  17  18  24  29  35  37  38  102 152 102 157 120
2   132 58  11  3   0   0   34  124 153 81  29  113 229 177 167 102 50  31  33  42  50  57  62  65  126 176 129 183 149
4   58  32  3   6   4   2   77  217 195 79  15  55  185 190 172 161 187 132 37  12  11  13  15  20  19  20  36  53  152 102
0   62  39  0   2   2   6   62  204 197 81  10  43  45  190 198 189 206 153 46  27  34  40  51  62  67  74  98  110 193 161
0   82  38  2   9   6   6   80  224 212 96  17  55  206 198 189 206 153 46  27  34  40  51  62  67  74  98  110 193 161
8   78  41  0   5   0   13  151 218 183 58  6   14  140 181 199 219 209 72  37  20  15  17  24  32  32  50  49  46  40
8   80  41  0   0   0   9   142 212 164 63  8   6   127 186 166 207 194 79  49  27  28  38  51  62  66  87  86  80  81
5   97  49  0   3   0   20  163 232 182 80  18  16  144 206 187 224 210 95  70  49  48  63  79  91  116 134 111 114
3   28  28  22  13  30  47  137 167 156 115 32  25  76  106 118 157 85  123 165 151 75  41  47  53  71  89  85  88  103
8   46  46  38  26  41  49  144 177 184 125 37  27  71  105 125 156 85  132 183 149 103 79  50  96  116 135 134 136 145
8   66  65  59  43  65  64  166 196 184 146 55  40  85  124 148 177 103 152 204 195 127 109 123 129 147 165 162 162 174
8   34  50  50  49  101 92  75  87  137 187 91  56  46  107 134 167 86  149 174 169 128 106 141 182 184 192 177 180 186
8   53  74  81  82  134 121 102 112 145 200 113 83  69  125 153 179 89  155 181 199 109 173 202 211 189 197 193 220 220 224 216 226 228
3   72  98  107 110 158 144 130 134 167 219 138 113 94  150 170 199 109 173 202 211 189 177 193 220 220 224 216 226 228
2   11  7   9   13  20  21  27  36  61  83  55  45  53  45  115 168 141 128 142 103 76  93  160 196 174 211 206 168 132
1   9   4   6   11  22  31  41  55  75  107 83  81  90  116 138 178 140 123 133 113 99  115 162 188 165 203 197 168 139
8   16  11  11  20  32  41  59  77  99  128 107 112 121 144 165 199 158 135 141 185 204 178 216 211 184 157
1   17  5   7   5   8   8   14  36  61  83  37  15  20  33  52  69  55  53  131 153 64  43  60  63  54  83  69  35  24
5   13  0   0   0   0   0   4   6   3   7   15  24  39  58  70  50  36  106 150 78  66  83  85  75  95  75  38  31
3   18  2   3   0   0   0   0   2   3   12  25  37  55  75  83  59  50  131 172 102 95  110 111 98  118 96  58  51
0   4   1   5   6   7   9   4   6   7   5   7   5   3   2   22  49  19  60  136 63  32  46  53  58  53  56  47  45
0   0   1   6   7   0   2   3   1   1   6   1   0   0   0   0   11  35  7   41  117 60  46  64  71  83  80  79  66  62
1   1   1   3   4   5   6   3   5   3   2   0   1   0   0   0   18  47  15  56  137 76  65  87  95  107 106 101 87  83
0   5   6   7   8   6   6   6   5   5   5   9   11  6   6   11  43  37  40  115 77  7   12  14  19  32  36  43
1   1   1   1   1   1   0   1   1   1   1   3   6   1   2   1   28  23  18  79  51  0   3   6   11  23  39  46  54
2   2   2   3   3   2   2   2   4   5   5   5   3   8   38  29  29  98  61  0   5   10  17  30  50  61  72
5   5   5   7   7   7   0   0   1   1   3   1   0   5   15  47  116 98  12  3   2   3   0   0   4
1   2   2   1   4   3   3   2   4   2   2   2   2   6   0   35  95  81  5   0   0   0   2
2   4   4   3   3   2   2   1   2   2   2   2   2   4   0   17  85  143 106 18  4   5   4   4  11  14
4   5   5   5   6   6   6   5   5   5   7   4   0   5   23  98  160 123 28  10  11  9   8   11  14
5   5   5   6   6   1   1   1   1   1   1   1   1   5   6   66  121 92  12  0   11  9   8   1   1   1
6   6   6   2   5   5   6   2   2   1   1   1   5   9   6   0   111 181 131 20  10  9   6   6   7   5   8   10
0   0   1   1   0   0   0   1   1   1   1   2   5   1   2   0   78  141 102 7   0   1   1   1   1   2   2
6   6   6   5   5   7   1   1   5   1   1   1   9   14  11  9   96  164 118 14  6   4   4   2   3   3   4
2   2   2   2   2   2   0   1   1   1   1   2   6   3   1   0   133 172 113 12  12  9   6   5   1   6   5
1   0   0   1   1   1   1   1   1   1   1   2   8   3   1   0   106 139 90  0   1   1   1   1   1   1
2   2   2   2   2   2   2   2   2   2   4   11  8   6   2   43  128 160 104 7   7   3   2   2   2   3   2
6   7   5   4   5   7   6   4   5   5   6   7   6   7   4   13  101 171 183 107 14  15  11  7   9   11  10  5
1   1   0   1   1   1   0   1   1   1   1   2   3   1   0   14  107 173 195 112 13  15  6   3   6   5   5   2
2   2   1   1   1   2   1   1   1   1   1   2   3   4   2   23  126 195 189 105 9   9   6   2   4   4   5   3
6   6   3   3   3   5   5   4   5   6   6   6   7   7   7   5   58  157 196 195 112 13  15  15  9   10  8   7   7
1   2   1   1   1   1   1   1   0   0   1   1   7   2   0   63  166 198 191 107 8   7   7   6   3   3   2   1   1
3   3   1   1   1   1   1   1   1   2   2   2   2   1   6   80  185 214 203 116 13  10  10  8   8   3   2   1   1
0   1   6   8   6   5   4   5   5   6   7   10  9   24  134 185 208 203 208 134 10  15  12  22  13  6   6   1   1
1   0   1   1   1   1   1   1   1   1   3   9   1   23  134 190 203 208 134 10  10  20  11  3   0   0   0
4   10  7   2   2   2   2   2   3   4   7   36  154 207 213 215 140 14  10  20  11  3   0   0   0
6   9   29  38  35  14  9   11  12  11  9   3   4   7   61  168 200 213 215 167 34  18  19  7   5   4   60
0   4   25  33  30  9   4   7   7   8   7   5   3   2   1   70  179 199 206 210 213 166 30  14  18  5   2   0   4   53
1   7   31  38  33  13  7   4   7   8   7   5   2   3   9   86  198 212 215 217 166 30  14  18  5   2   0   4   60
11  12  21  28  33  25  20  16  15  15  15  14  11  14  100 192 212 217 218 161 31  18  10  4   5   5   75  105
6   7   16  24  29  26  20  13  10  10  9   8   6   12  114 195 205 207 207 152 26  10  4   0   1   5   5   78  103
8   8   18  26  30  30  23  16  12  12  13  11  9   22  132 215 214 216 159 26  14  7   1   1   5   78  103
6   7   7   13  29  35  27  14  13  14  17  22  14  48  155 205 218 219 216 134 24  15  7   6   1   54  111 18
2   3   4   3   9   24  30  21  7   8   9   10  13  9   50  161 201 206 207 204 123 13  7   1   1   0   49  104 11
3   4   4   4   10  28  33  23  9   10  13  14  16  69  180 215 214 214 213 130 13  7   1   1   0   59  113 18
2   2   2   4   9   22  28  27  7   8   9   11  17  22  107 208 107 19  12  8   5   7   104 58  63
0   0   0   0   1   5   18  24  7   2   4   12  89  186 207 205 206 196 98  8   4   2   1   4   110 60  68
0   1   1   2   6   22  19  9   2   4   10  16  17  18  109 203 216 212 212 203 101 11  4   2   3   88  110 66
0   1   1   5   3   8   38  64  31  6   7   8   8   26  68  136 205 226 221 186 82  11  7   7   3   25  106 37  140
5   0   1   3   1   0   3   27  57  25  0   1   1   4   9   28  83  143 198 208 204 175 53  3   2   1   0   102 31  137
2   2   1   1   5   35  64  30  4   1   7   8   39  101 101 206 211 208 182 60  11  11  11  28  111 41  151
7   4   5   2   13  67  98  73  17  17  14  4   17  112 174 171 194 218 220 138 19  15  7   6   42  104 51  162
1   0   0   0   0   11  61  92  67  14  6   4   3   35  146 211 196 200 200 212 211 130 13  13  1   1   37  100 44  158
3   3   2   1   9   38  89  87  36  8   5   8   61  138 181 209 217 213 214 194 61  6   2   1   1   43  90  52  161
1   1   0   0   6   23  68  67  23  8   7   14  73  140 187 204 210 203 202 215 176 51  6   0   7   1   41  90  52  161
8   1   3   2   1   6   35  46  34  4   4   3   9   43  93  172 202 209 211 189 53  7   3   1   0   47  93  63  180
3   13  22  45  111 134 85  21  20  56  120 185 216 221 222 215 203 118 17  10  9   7   41  95  63  167
0   6   13  34  92  111 66  12  21  62  128 188 215 209 206 207 202 192 108 8   2   1   0   36  93  40  158
1   12  21  44  110 131 78  18  30  78  152 208 223 216 213 211 206 197 112 11  4   3   3   40  97  48  155
1   14  91  167 203 203 124 68  152 196 217 226 230 230 227 226 212 156 40  17  13  9   8   24  101 43  150
0   12  91  166 188 115 71  156 195 212 212 209 210 206 205 204 149 33  10  7   3   0   19  97  41  155
1   14  87  184 215 217 219 222 206 203 221 213 212 208 206 203 149 33  10  7   3   0   19  97  41  155
5   57  151 196 212 223 223 196 196 232 231 233 236 232 229 227 192 68  18  20  11  10  8   6   7   7   81  53  88
5   4   66  162 200 208 213 216 193 190 215 214 210 207 202 206 178 72  18  10  8   6   7   7   3   80  54  76
11  87  184 215 217 219 222 215 204 213 210 210 210 208 182 61  11  14  5   4   3   7   81  68  92
5   41  102 164 201 221 226 233 234 216 214 234 243 245 244 237 213 104 14  11  10  10  8   8   9   4   43  95  23
5   50  119 176 202 213 219 216 222 225 211 217 216 214 212 196 94  9   2   1   4   2   3   47  60  94  23
8   70  147 196 213 219 216 222 230 218 213 221 221 217 214 212 196 94  9   2   1   4   2   47  102 34
8   78  88  130 165 173 178 159 148 141 148 153 155 155 147 137 135 19  8   7   6   5   6   6   6   11  68  38
6   93  101 153 163 168 169 149 138 134 131 138 137 137 135 90  11  14  3   4   3   3   4   11  67  36
0   110 118 148 171 174 174 151 139 135 133 139 138 137 137 135 91  14  3   4   3   3   4   11  71  39
```

GO WATANABE

JAPANESE, BORN 1975

face ("portrait")–10, 2006–07.
Digital print, translucent lightbox, 53 ⅛ x 49 ¼ x 7 ⅞ in.
(135 x 123 x 20 cm)

Introduction

Tech-

nology has driven the art and science of photography since the invention of the medium in the early nineteenth century. Digital photography is the most recent development, and in many ways the most perplexing and provocative. New cameras, printing techniques, and software allow artists greater freedom than ever before to take photographs of the real world and to generate images from the imagination. At the same time, the capacity to seamlessly merge and morph pictorial elements has social, political, and legal implications. As a challenge to photography's documentary nature and as a catalyst for creativity, digital photography has a profound impact on visual culture.

Artists have long promoted innovation, as visionaries and beta-testers of new technologies. Never has that been more true than now. Among the artists working with digital photography, some employ it as an aesthetic tool, others as a platform for investigating new areas of photographic practice. Some

treat it as a vehicle for waging social or political critique; others look to it as a subject in and of itself. For the purposes of this book, the term "digital photography" will refer to images that transform light into coded data. But what does digital photography mean in the bigger picture? Is it a medium in its own right, autonomous and separate from all photographic processes that have come before, or is it another development in a long trajectory of technological innovations? What impact does it have on how we view, understand, and make photographic images?

■ ORIGINS AND ACCESS: FROM ANALOG TO DIGITAL

Before surveying the range and complexity of digital photography, it is useful to try to imagine a world without photographs. This is not an easy task, especially given today's glut of visual images. And yet before 1826, when French inventor Joseph Nicéphore Niépce made the first known photograph—a fuzzy view of rooftops seen from the window of his study (opposite)—the only imagery of people, still lifes, and landscapes were described in words or artists' renderings, often with remarkable precision, but nonetheless interpreted with language, pigment, graphite, or ink.[1] With the advent of photography came the capacity to make a direct transcription from life—hence its name, which comes from the Greek words, photo (light) and graphein (writing). This new form of picture-making, this "writing with light," forever changed the way the world was seen and experienced. It also provided pictures and knowledge about people, places, and things never before imagined.

The origin of computers can be traced to 1800, with the invention by J. M. Jacquard of a loom controlled by punched paper cards. Three decades later, in 1833, Charles Babbage designed what he called an "Analytical Engine," a machine that would perform mathematical operations on information and instructions that had been fed into its memory.[2] Both devices are now considered the precursors to the modern computer. There is something fitting about the idea that mathematical and light-based imaging technologies emerged at around the same time in history—as though they were destined, one day, to be joined at the hip.

Color digital print reproduction of Joseph Nicéphore Niépce's
View from the Window at Le Gras.
Harry Ranson Center and J. Paul Getty Museum,
June 2002. 8 x 10 in (20.3 x 25.4 cm)

———

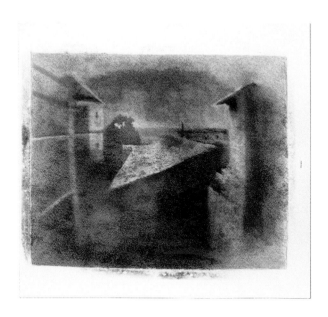

Gelatin silver print with applied watercolor reproduction
of Joseph Nicéphore Niépce's *View from the Window at Le Gras.*
Helmut Gernsheim & Kodak Research Laboratory, Harrow, England,
March 20–21, 1952. 8 x 10 in. (20.3 x 25.4 cm)

The photography we have known over the past 170 years is called "analog" after the process of creating a likeness of a subject . . . something analogous or similar to something else. Analog photography starts with light transmitted through the lens of a camera via optics and physics onto a light-sensitive support (or exposed directly, as in the case of a photogram). Commonly, the support is photographic film, which becomes the storage system for the image captured during exposure. That film can then be used to make multiple prints and enlargements. The resolution of a printed enlargement depends upon the silver halides in the film and the magnification of the image: the larger the print, the larger the grain, and consequently the less sharp and continuous the tone. Photographic film and prints are physical objects that require care in handling and storage. Their dissemination is most often through display of the physical photographic print, projection of the image in the case of transparencies, or reproduction on the printed page.

In digital photography, the construction of a likeness is based on code and algorithms. Information from the physical world that starts with a transmission of light is received by sensors in a digital camera and converted into data that is stored as zeros and ones in a computer memory. Unlike the grain that photographic film is made up of, a digital image is comprised of picture elements that are independent, discrete, tiny squares. Each pixel, as these units of information are called, can be individually altered, molded, and modulated in an infinite variety of ways.[3] Multiple images stitched together and pristine pictures cleared of distracting details are only two of countless possible results of digital manipulation (below & opposite). Electronic images can be displayed on a computer or projected, made as photographic prints, or transmitted via the Internet. In short, analog and digital photographs may start with the same thing—with light and a subject that exists in the physical world—but from the

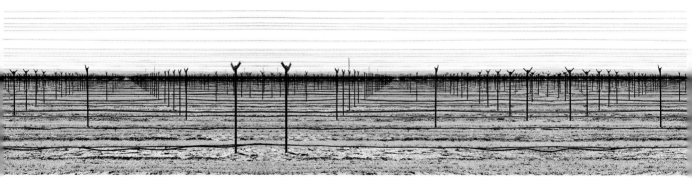

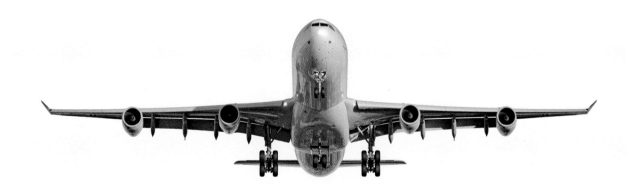

JEFFREY MILSTEIN
AMERICAN, BORN 1944

(above) *Swiss International Airbus, A340–300*, 2007.
Pigmented inkjet print,
30 x 60 in. (11.81 x 23.62 cm)

———

TOM BAMBERGER
AMERICAN, BORN 1948

(below) *Wires*, 2002.
Pigmented inkjet print,
23 ¼ x 108 in. (59.06 x 274.32 cm)

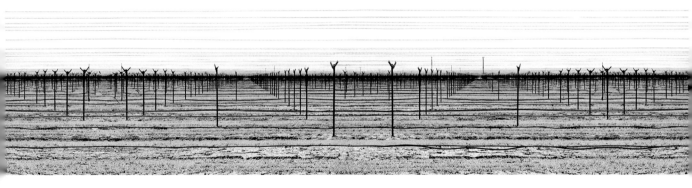

moment that light enters a camera's lens, the resemblance ends. Rather than render a trace of light, digital photography represents a transmission of information; an encryption into code versus a transcription of nature.

It took well over a century from the conceptualization of digital computing in the early nineteenth century, to the building in 1946 of the world's first computer, the University of Pennsylvania's Electronic Numerical Integrator and Computer. It took another five years for a computer to be patented for commercial use (the UNIVAC).[4] Over the next decade, the space race and military intelligence efforts advanced digital technology. When, in 1957, the Russian satellite Sputnik was sent into the Earth's orbit, activity on earth could be observed from outer space for the first time. Within three years, the US Air Force launched its own reconnaissance satellite outfitted with a single panoramic camera to focus on territory of political significance around the globe. Once rolls of film were exposed, they were ejected in canisters that floated towards Earth and were retrieved in mid-air by helicopter. Today we receive images of the far reaches of the universe by electronic transmission from the Hubble telescope. It is hard to believe that only sixty years ago film was physically transported into space and literally "captured" on its way back to Earth in a high-risk maneuver worthy of a spy movie.[5]

In 1975, the algorithm that makes it possible to render, on computer, an object with smooth contours and little pixel breakdown was invented at the University of Utah, opening up fresh territory in graphic imaging and providing a roadmap to the future. By the early 1980s, computer power had grown exponentially and image-processing systems, such as Scitex, allowed users to alter existing pictures or create new realities with convincing results. At first, digital cutting and pasting of photographic images was employed primarily by the graphic design and commercial advertising industries. But in February 1982, the cover of *National Geographic* presented two Egyptian pyramids digitally repositioned to fit the vertical format of the magazine. For a publication whose century-long mission was to provide excellence in reporting, photography, and map-making, to electronically tinker with reality heralded the beginning of a new era.[6]

Also in 1982, the personal computer was named by *Time Magazine* as "The Man of the Year." In 1984, Apple's Mac was introduced as the "Computer for the Rest of Us," further reinforcing the democratization of information by providing tools for consumers to become content providers. Aldus PageMaker, a graphics application that launched the era of desktop publishing, was released shortly thereafter, and both Adobe Photoshop 1.0 and the World Wide Web were introduced in 1990. That was the year of the Persian Gulf War, when government control of photographers' access to the battlefield was at its zenith. By the turn of the century, it was harder and harder for anyone, anywhere, to be able to fully corral or control the dissemination of photographic imagery

Photography and Representation: A Historical Perspective

One of the debates about photography that have been ongoing since its invention is its relationship to the real. In the 1960s, film critic André Bazin wrote that photography ". . . does not create eternity as art does, it embalms time. . . ."[7] In 1981, theorist, philosopher, and culture critic Roland Barthes asserted, "Reference is the founding order of photography."[8] A common fear about digital photography is that it corrupts or threatens analog photography's standing as the principal medium of resemblance in the modern world. If we can alter any scene or create new realities from disparate parts, how can we trust what we see? And yet, accurately depicted reality has not always been the ruling principal of photography. Indeed, historical precedent exists for many of the characteristics we think of as central to digital photographic practice: from enhancing a photograph to making composite images; from disseminating widely to engaging in interactivity.

Since the medium's beginnings, practitioners have altered, collaged, and appropriated photographs, sometimes to better mimic the natural world, other times for aesthetic or narrative effect. Early daguerreotypists often applied pigment to the surface of the monochrome plate to make a portrait subject look more lifelike—a blush to cheeks or color to eyes, for instance. Countless artists have combined negatives. In *The Two Ways of Life* (1858, p. 30), Swedish-born photographer Oscar G. Rejlander, depicted virtue and sin in a

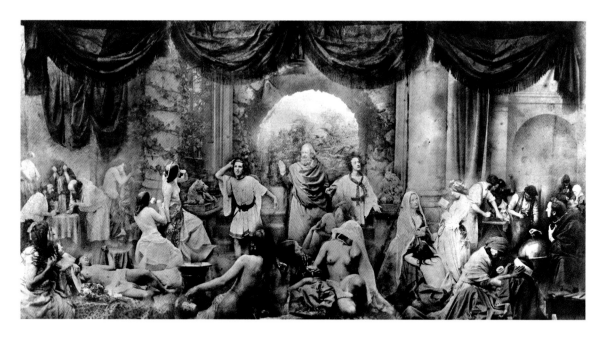

panoramic image made up of 32 glass plate negatives of subjects photographed at different distances according to the desired scale of the final composition. Given the ease with which we can now cut and paste on a personal computer we may appreciate this work all the more as a narrative and technological tour de force.

In addition to providing multiple tools for taking or shaping photographs, computer technology offers easy-to-use cameras and unprecedented speed, ease, and choice of platforms for disseminating digital images. A photographic revolution of a similar kind took place in the late nineteenth century. In 1888, George Eastman introduced the Kodak No. 1 box camera, a compact and relatively inexpensive device that was pre-loaded with film. No longer was it necessary to have expensive equipment or special training to make photographs. "You push the button, we do the rest" was the promise Kodak made to customers in the first appeal to consumers to consider photography as a

user-friendly, accessible medium for all. The popular craze for photography that followed was led by people who made pictures of family and friends—on the beach, in cars, and in the back yard at home. They tilted the camera up, down, and to the side, often unwittingly cutting off the tops of peoples' heads or omitting important details.

Such photographic "mistakes" revealed new subjects and new forms, forever altering the way artists and the public considered photographic representation. They also ushered in a new genre of photography, the anonymous snapshot. With the widespread use of the half-tone printing process in the 1890s, photographs soon became regularly reproduced on the printed page. Together, the hand-held camera, half-tone reproduction, and broad distribution of images in newsprint led to a revolution in picture consumption. Not only were photographs taken by an ever-greater number of people, they were seen by an ever-larger audience.

Some pictures from the printed page served as raw material for early twentieth century Cubist, Dada, and Surrealist collages that challenged authorship and pictorial tradition. As another precursor to the kind of sampling that takes place in today's digital image construction, we may also look to Robert Rauschenberg's utilization of found imagery in his *combines* made of three-dimensional objects and everyday materials in the 1950s and '60s. A more recent antecedent can be found in postmodern appropriation of the late twentieth century.[9]

Historical precedence exists for two other aspects of digital imaging: its immediacy and effectiveness as a tool for interaction and collaboration. In 1947, the invention of the one-step process for producing a finished photograph was announced by the Polaroid Corporation. Long before digital technology made instant viewing a standard part of picture making, Polaroid cameras and film gave rapid results. Moreover, with instant imaging a photographer could share pictures with a subject on the spot, and offer a photograph to take away, which opened the door to a sense of joint authorship not previously possible. By the time cameras in cell phones allowed users to instantly capture, store, and send pictures within the blink of an eye, the appetite for instant imagery

once cultivated by Polaroid photography had grown to be voracious and wide-spread. How this all-pervasive image culture translates into the world of art is a story in and of itself.

■ BIT BY BIT: ART PHOTOGRAPHS IN THE DIGITAL WORLD

In the history of photography, the intersection between technological invention and creative application is often where some of the most interesting art can be found. Those who laid the groundwork for digital photography early on came from disparate fields, including medical research, video, textiles, as well as photography. What they had in common was an interest in computer-based imaging as a tool to be used at the service of their ideas and imaginations. While there are countless ways of addressing the range of digital photographic works made over the past 25 years, the following three broad categories will serve as points of departure for our inquiry.

Socio-Political Commentary

Nancy Burson worked in the late 1970s with scientists at the Massachusetts Institute of Technology to develop software that synthetically aged a human face; a technology that law enforcement officials subsequently used to locate missing children and adults. In 1982, Burson became one of the earliest artists to use the computer when she employed it to make art works that blended the individual facial characteristics of five well-known movie stars for each of two composites to create a generalized portrait of beauty from different eras (p. 66). The first features Bette Davis, Audrey Hepburn, Grace Kelley, Sophia Loren and Marilyn Monroe. The second features Jane Fonda, Jacqueline Bisset, Diane Keaton, Brooke Shields and Meryl Streep.[10] Shortly thereafter, Burson weighted the image density of a portrait of a Caucasian, an Asian, and a Black male according to population statistics of the time, to produce a composite she titled *Mankind* (1983–85, p. 67). Burson's art may be viewed as a critique of the homogenization of appearances and identity in the modern world. By providing hybrid faces that look both vaguely familiar and alien, it also suggests the realm of dreams or fiction; and in its diffused pixilated appearance,

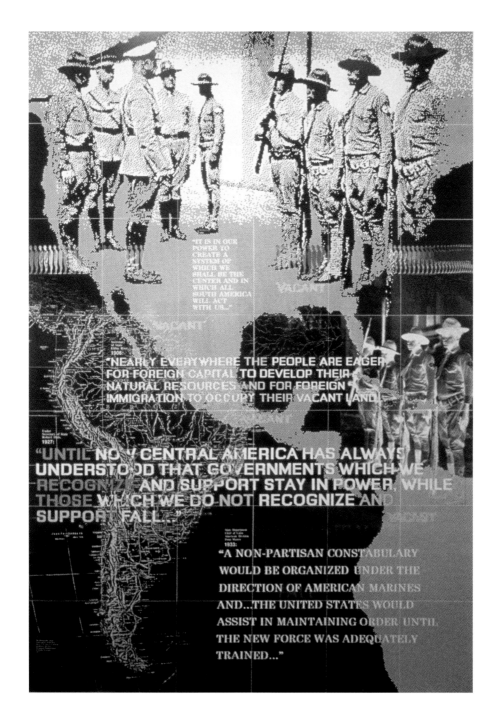

ESTHER PARADA

AMERICAN, 1938-2005

Monroe Doctrine: Theme and Variations, 1987.
Gelatin silver print from digital files, 72 x 48 in.
(182.9 x 121.9 cm)

it draws attention to the morphing of multiple images that are integral to the concept and content of this work.

Another pioneer in computer imaging, Esther Parada, made art with macramé before becoming a photographer, which she considered integral to her work with digital photographic practice. To generate one of her seminal pieces, *Monroe Doctrine, Part One: Theme and Variations* (1987, p. 33), Parada started with a 1927 photograph of U.S. Marine Corps officers reviewing the newly trained Nicaraguan National Guard. Additional text and images were then digitally woven into the piece at different degrees of image resolution, to provide a critique of U.S. intervention in Latin America. "This strategy of resolution shift," Parada remarked "simulates or parallels the relationship between public and private, historical and contemporary events."[11]

Roshini Kempadoo utilizes a similar strategy of creating digital collages of non-art imagery to address the economical and cultural impact of unification on Europe's black communities (p. 102). In more recent work, Kempadoo superimposes photographs made from video footage of actors staged in a film studio over pictures she shot in Trinidad, to invite a dialogue about the relationship between the observed and observer, the protagonist and narrator (p. 103). Chris Jordan makes pictures with environmental concerns and social responsibility at the root of his practice. Unlike Oscar G. Rejlander's assembly of 32 glass plate negatives in 1857, Jordan multiplies objects shot in the studio by the thousands to give visual form to statistics about ecological excess and waste (detail, opposite, and pp. 12–13).

Other artists who give voice to oppression and social strife, mysticism and hope include Stephen Marc (pp. 122–23) and Pedro Meyer (pp. 134–35). Sheila Pree Bright makes composite photographs with toy dolls and women of color that emphasize the difference between the ideal and the real (pp. 64–65), whereas Annu Palakunnathu Matthew and Hank Willis Thomas take the language of advertising as a platform for suggesting how generalizations around race, gender, and ethnicity are reinforced by media imagery. For her multi-media installation, *The Virtual Immigrant* (2006, p. 125), Matthew uses digital stitching tools to make Lenticular photographs about call center work-

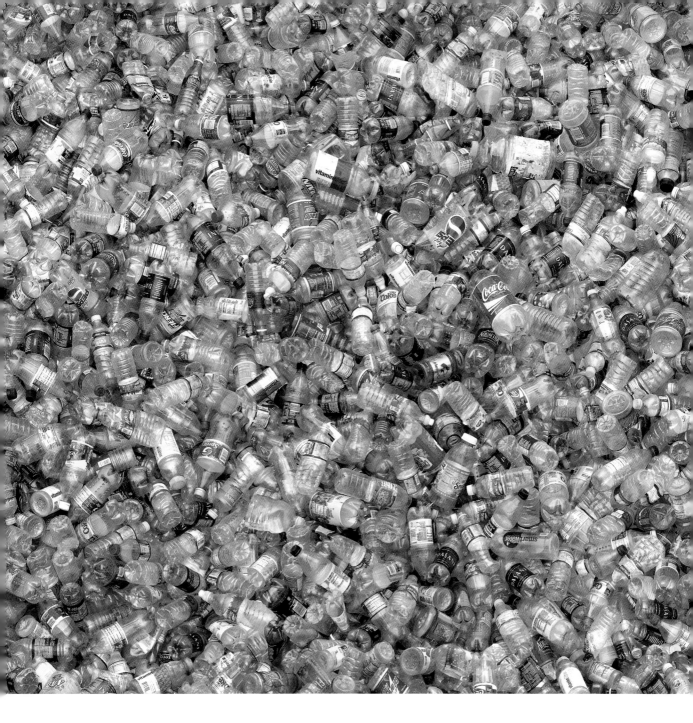

CHRIS JORDAN
AMERICAN, BORN 1963

Plastic Bottles (detail), 2007.
Pigmented inkjet print, 60 x 120 in.
(152.4 x 304.8 cm)

ers in India, who adopt American dress, language, and behavior for work, but maintain Indian cultural practices at home. Thomas's series *Unbranded: Reflections in Black by Corporate America* focuses on magazine ads from 1969 to now, with text and product information digitally erased to highlight racial typecasting (1968–2008, p. 154). Most of these artists feel they could have produced the pictures seen here without digital means, but many assert that the computer changes the way they work and can serve as a catalyst or facilitator in their art making. Nic Nicosia, for instance, remarks of the small-scale maze he constructed and photographed for the digital composite *Untitled #10* (2002, p. 140), "I could have built the maze full size, I suppose, but I wouldn't have, at least not for this particular body of work."[12]

Using molecular biology at the service of his art, Iñigo Manglano-Ovalle employs photographic samples of his own DNA along with that of his father and his mother, then color-codes and enlarges them to form a series of non-figurative photographic portraits (p. 118). By employing genetic material, he does away with the outward physical traits that are often used to evaluate an individual; including skin color, age, or style of dress. Helen Chadwick embraces science and nature in a series that emerges out of feminist investigations of the body. Her *Viral Landscapes* feature imprints on canvas of paint tossed on ocean waves digitally integrated with photographic seascapes and microscopic images of cells from the artist's body (1988–99, p. 72–73).[13] Expressionistic and performative, these digitized photographic works make up a hybrid form of deeply personal art. "Photography is my skin," Chadwick has written. "As membrane separating this from that, it fixes the point between."[14]

One of the factors that distinguishes the work of artists using digital means from previous photographers is unprecedented access to databases and archives. Another element that differentiates the current technological climate from the past is how images are stored. Analog pictures are captured on film made up of silver halides with visible grain structure. Digital captures are translated into numbers and stored on a memory chip that allows for higher resolution at a broader range of scale. This affords many photographers the ability to present their work in much larger prints and projections than ever

before. But perhaps the most significant development is the electronic dissemination of photographs—online or on a computer monitor; at home or in a public venue—which has forever changed the way we think about and interact with photography.

Several artists have recognized the potential in these new distribution networks for breaking down socio-political barriers and creating an open forum for dialogue and debate. In 1996, photographer and installation artist Lorie

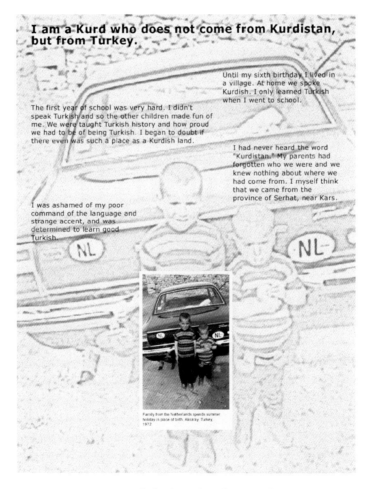

Susan Meiselas (American, born 1948),
screen shot of *akaKURDISTAN*, 1998–ongoing.

Novak launched *Collected Visions*, a participatory Internet project that explores how family photographs shape our memories.[15] In 1998, documentarian and Magnum photographer, Susan Meiselas introduced *akaKURDISTAN*, a borderless site designed to draw together the exiled Kurdish community and to invite international archivists and travelers to share images and experiences of Kurds and Kurdistan at a time when practicing native customs—even owning photographs of the past—was forbidden by the ruling government of Iraq (p. 37)[16]. By providing an online location for cultural exchange, Novak and Meiselas gather images and information into virtual archives, where stories are told by multiple voices, adding complexity and texture to personal experiences and historical events.

Other Dimensions, Other Worlds

The desire to tell a story with photographs is strong among artists using digital technology, perhaps because computer imaging tools provide more options than ever before to create characters and shape narratives. Some artists look to their family history, personal relationships, or everyday lives for source material. An early innovator in what we might think of as "domestic surrealism" is Martina Lopez, a second-generation Mexican American, who cuts and pastes nineteenth century portraits of unknown individuals into barren landscapes of her own design, or features herself, her husband, and her children as the subjects of portraits staged and enhanced to reference nineteenth century tintypes (pp. 112–13). Julie Blackmon (pp. 62–63), Ben Gest (pp. 86–87), and Angela Strassheim make quirky pictures of what appear to be the simple day-to-day activities of family and friends, but something is awry. Perspectives are off and angles are skewed. In the case of Strassheim's photograph of a father and son grooming in front a bathroom mirror, for instance, the camera is missing in the reflection (p. 152). Strassheim's most recent work, which utilizes forensic technology to call forth evidence of former violent crimes, inflects the present with the past (p. 153).

Adolescent daydreams, fairy tales, and science fiction provide fertile ground for digital translation, in part because reality is more readily suspended when

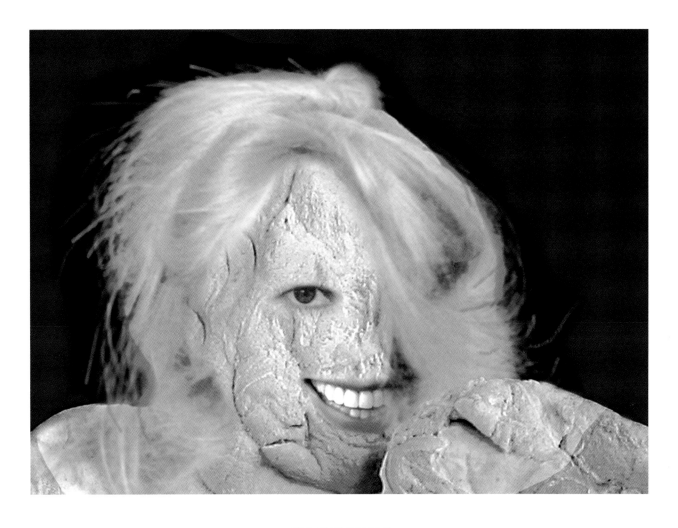

IDA APPLEBROOG

AMERICAN, BORN 1929

Emma, 2007. From the series *Photogenetics*.
Mixed media on arches, 30 ¾ x 44 in.
(78.11 x 111.76 cm)

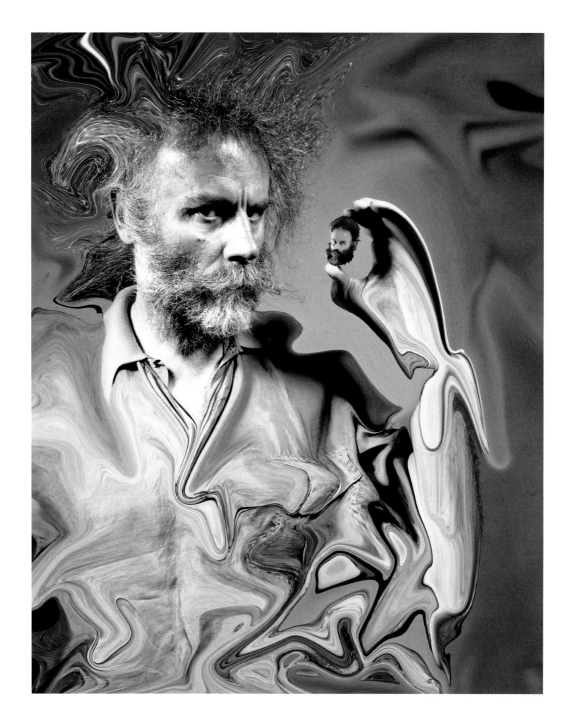

LUCAS SAMARAS
AMERICAN, BORN 1936

Head Chest Liquid, 2002.
Pure pigment on paper, 28 ⅛ x 22 ¾ in.
(71.4 x 57.8 cm)

fantasy is at work. Anthony Goicolea's and Mary Mattingly's digitally constructed photographs of remote landscapes conjure up survival strategies in an apocalyptic world (pp. 90–91 and pp. 126–27). Loretta Lux's hyper real images of children in eerie reverie suggest a deep psychological reflection not commonly associated with childhood (pp. 114–15). Digital twins, avatars, and composites of idealized body parts, seen in the work of Wendy McMurdo (pp. 132–33) and Keith Cottingham (pp. 74–75), draw upon longstanding practices in art history of using doubles, or alter egos, to call into question notions of the "self" as a coherent, integrated whole.

So, too, do the images of artists who utilize computer imaging to create distorted depictions of the human figure. Works by Ida Applebroog (p. 39) and Lucas Samaras (opposite), for instance, suggest an anti-classical, gothic sensibility towards the body. Never one to shy away from iconoclastic uses of photographic materials, Samaras has slit photo paper and poked Polaroid film in the past. Now, he wields computer technology to form images of himself as a protean shaman or shape-shifting imp. Equally fantastic are Margi Geerlinks's images of a young woman knitting the body of a child and of a mature woman applying youthful skin with a makeup pad (pp. 84–85), or Jeff Wall's oversized nude on a stair, which takes the figure to gargantuan proportions (p. 162).

Amplifying and enhancing existing realities is one thing: creating digital environments out of whole cloth is another. Peter Campus, well known as an innovator in video art since the 1970s, was among the earliest artists to produce digital photographs that provide visions of other dimensions and other worlds (pp. 68–69). Also early on, the artist collaborative Aziz + Cucher (Anthony Aziz and Sammy Cucher) shaped pictures of what looks like Caucasian skin into structural forms that resemble architectural interiors. Their more recent works consider the landscape as a permeable membrane (pp. 58–59). Entering into the realm of complete virtual fabrication is Craig Kalpakjian, who uses architectural design programs to render an interior on the computer, and then employs a function of that program, which simulates a camera, to capture a photographic image of the space (p. 100). That image is then saved as a digital file, which can be downloaded to a printer that outputs the digital

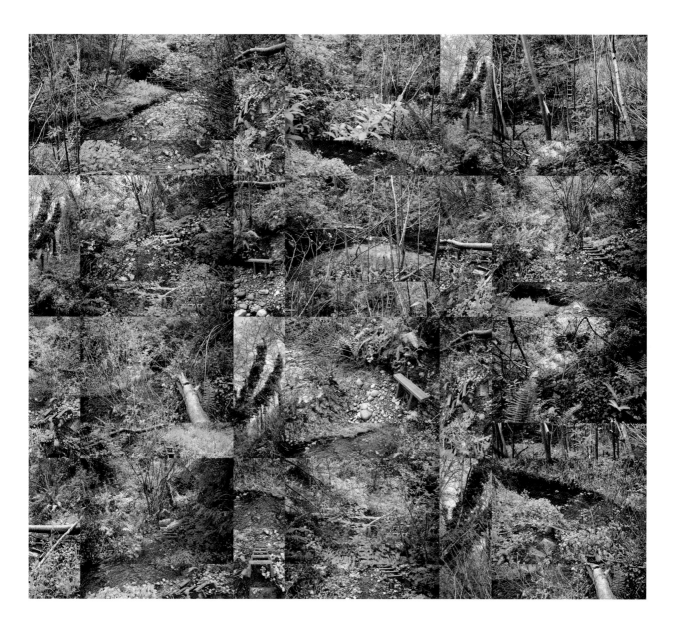

PAUL BERGER

AMERICAN, BORN 1948

Warp & Weft Ground: Spring 3, 2002.
Archival iris print, 35 x 39 in.
(88.9 x 99.1 cm)

information onto light sensitive photographic paper (the only truly direct link to the photography we know from the past). What is the point, one might ask, of creating an image of something that does not exist, to look like a photograph of a place that does? Is it mere trickery, or does it lay bare an essential dilema in photographic art in the digital age . . . that time and space are not fixed, and that our definition of photography as a transcription from life must now be more broadly defined?

Numerous artists make photographs from life, then digitally collapse time or stretch dimension. For his series, *Warp & Weft* (2000–2002, opposite), Paul Berger adopts a weaving metaphor for the arrangement of photographs. He remarks, "It is a way of alluding to how we see and process the multiple perceptions that make up our daily life; the front and the back, that which remains vivid and distinct on top of that which becomes merged and integrated."[17] Scott McFarland's panoramic image of a country garden pictures vegetation at different stages in the seasonal growing cycle, all in the same frame (pp. 128–29), whereas Noriko Furunishi's vertical landscapes upend perspective and do away with logical progressions from foreground to middle ground to background (pp. 82–83).

Digital images such as these challenge one of the oldest pictorial traditions in the history of art: Renaissance perspective. Introduced in the fifteenth century, it offers a view seen from a single point in space and time that presents subjects and objects in logical relationship to one another relative to scale. Analog photography works on the same principle, with the camera lens and moment of exposure as the points of reference. Digital imaging, on the other hand, offers new ways in which the three-dimensional world can be rendered on the two-dimensional surface of a picture plane. Roy McMakin, for instance, employs a shallow depth of field to underscore the subjectivity of a single point of view when photographing an angel wing begonia from the focal point of the pot's centerline as it turns full circle, 90 degrees at a time (pp. 130–31). "I approached this like a science experiment, with the exposure, camera placement, lighting, and printing strictly controlled to be exactly the same. But the results of the experiment were already known: there is no such thing as

an impartial view. In the end, the work points to the futility of attempting to document something accurately."[18]

Isaac Layman, on the other hand, photographs the 26 drinking glasses in his kitchen cabinet, and digitally repeats them with multiple points of focus, to yield a still life of opulent grandeur that recalls the mechanics of the human eye (p. 109). Unlike a camera lens that, depending on the depth of field, can capture objects at different distances in focus, our eyes can only focus on one thing at a time. To understand the volume of a room, we scan the space and the countless registrations of what we see are put together in our mind's eye as volume, depth, and dimension. By presenting sharply rendered objects in multiple picture planes, Layman's *Cabinet* (2009) offers a mesmerizing quilt of images that is more akin to our experience of the world, than it is an accurate depiction of a particular place, space, or set of things.

Reflections on the Medium Itself

Of the artists who have employed digital means over the past 25 years, many have engaged with conceptual issues and questions underlying the medium of photography as a whole. In the 1990s, the collaborative team, MANUAL (Suzanne Bloom and Ed Hill) referenced one of photography's most common uses—as a tool for reproduction and representation. They took as a point of departure Nicolas Poussin's *The Arcadian Shepherds*, the well-known seventeenth-century painting that depicts shepherds, in an idealized landscape, inspecting the inscription on a tomb, which warns "Et in Arcadia ego" ("I am even in Arcadia"), reminding them that death exists even in this blissful place. In one of a series of images, *Et in Arcadia Ego: Topology of the Pastoral*, MANUAL digitally duplicated the painting as an out-of-focus reproduction and a topographic map (1998, p. 120). On the one hand, the digital rendering of the painting calls into question the authenticity of any single form of representation. On the other hand, the digital blurring of an idyllic life and landscape may be seen as a metaphor for longing and loss. A piece from a later series charts the sight and sound of Bloom walking in the woods (p. 121). "Rather than combining the visuals and actual sound," MANUAL remarks, "we rep-

resent the audio via the computer sound wave display . . . so there is a tighter parallel between what you see and hear. But still, they each require the viewer to deal with distinctly different classes of representation and information."[19] In a similar spirit of inquiry, Sherrie Levine digitally duplicates a canvas by nineteenth century French painter Paul Cézanne (pp. 110–11), and Idris Khan morphs into one image all the pictures from Bernd and Hilla Becher's 2004 series *Gable-Sided Houses* (p. 104).

Using the art of others as a source of content or inspiration has been a long-standing practice in the arts, but in photography it comes with strings attached. Authorship of lens-based images is safeguarded in the media and copyright infringement is debated in the courtroom. With the proliferation of image-sharing tools, however, it is becoming more and more difficult to police who uses what and how. In *Children Fleeing Napalm Strike, Modified—1972, Huynk Cong "Nick" Ut* (2000, p. 94) Jon Haddock digitally erases the figures from one of the most iconic photographs of the Vietnam War. The title alone gives us a clue to the subject and prompts us to conjure up the picture from our visual memories. The image may be copyrighted, but we share joint ownership of it in our collective consciousness. In a piece from a more recent series, *RGB Grid*, Haddock uses a frame from the Zapruder film of the assassination of John F. Kennedy that was at the center of a legal battle over what constituted "fair use" of photographs and films (p. 95). "These images are made up of the numeric values that represent the levels of red, green, and blue in each pixel of the source image," Haddock remarks. "The idea was that since RGB values run from 0 (black) to 255 (white)—and since 0 takes up less physical space than 255—the source image would still be visible in a matrix of values."[20]

The terminology Haddock uses here is familiar to those who know the workings of digital photography—who understand the mathematical encoding of information into picture elements. But for those new to the subject, finding metaphors for the difference between analog and digital is challenging. First and foremost analog takes into account the intervals between values (our body temperature index, for instance, is 98.6: not 98 or 99). Analog also encompasses nuances of duration. If we envision analog imaging in terms of a clock with

hands that tell time, we see the current moment relative to other minutes in the 12-hour period. A digital clock, on the other hand, is a closed system: we see a notation of the exact time at that particular moment distinct from any continuum. The broad, open-ended quality of analog timekeeping is absent (which may be why digital watches were a passing fad: our desire to visualize ourselves in the full spectrum of time remains strong).

Yet another way to think of digital information in photography is to call to mind a work of art molded by the human hand that exists in the physical world: for instance, Rodin's bronze sculpture *The Thinker* (1880). Now picture that subject rendered in plastic Lego building blocks. The first is an organic shape with rounded forms of a seated man in contemplation, elbow poised on his knee with chin in hand. The second is an object composed of individual geometric units that may resemble the original figure in space, but is limited to a structural system. What allows digital photography to better render the physical world is that pixels get smaller and smaller with technological advances, resulting in images that are less static and more like the continuous tone of analog photography.

Photographs that make visible the infrastructure of digital imaging (the building-block version of analog pictures) include Thomas Ruff's pictures inspired by jpeg compression software of found photographs broken up into pixilated squares (p. 146), or Takeshi Murata's photographs from horror videos he creates for the sole purpose of capturing digitally interrupted stills: the videos are then deleted (opposite). Sean Dack captures Internet images mid download and uploads intimate self-portraits by young women that become public when the subjects post them online (pp. 76–77). Other artists who extract elements from existing media include Birgit Rathsmann, who samples clips from Warner Brothers's *Roadrunner* cartoons, reverses the values and displays the works in a grid, referencing the typological photographs of the Bechers and paying homage to films and animation of the American West (pp. 144–45).

Jason Salavon, on the other hand, compresses the dominant color of each frame of James Cameron's 1997 film *Titanic*, to produce *The Top Grossing*

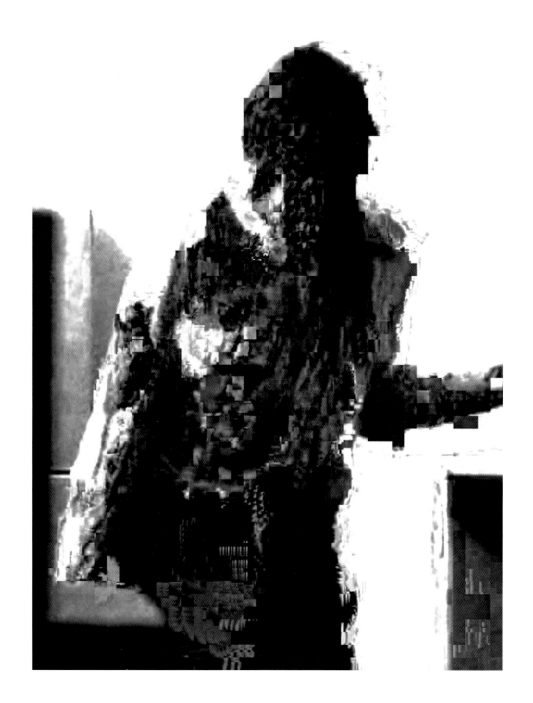

TAKESHI MURATA

AMERICAN, BORN 1974

001, 2007.
Pigmented inkjet print, 30 x 23 in.
(76.2 x 58.42 cm)

Film of All Time, 1x1 (2000, p. 148). From upper left to lower right, we see the entire film's narrative through a palette of color. A 3-D compression of space and time is represented in Salavon's reconstruction of Chicago's downtown Loop area, made up of interior and exterior photographs of over 500 buildings spanning the city's 175-year history (p. 149). Expanding beyond our immediate experience, Thomas Ruff generates mysterious compositions by downloading and hand-coloring black and white photographs of Saturn (p. 147), and Mungo Thomson harvests pictures taken by the Hubble telescope and interpreted by NASA scientists, then reverses their values and displays them as murals, effectively transferring a sliver of deep space to the walls of our earthly world (opposite).[21]

What about artists who make virtual spaces of the physical world here at home? In *PanCam-006* (2008, pp. 60–61), Paul Berger features a dog run as a cylindrical space in a digital world that we can view from any number of positions. Likewise, Victor Burgin combines countless photographs he took of abandoned areas in Berlin's Tempelhof airport, with the camera shifting direction to simulate a physical experience of the space in real time. He then constructs a panorama on the computer and uses a virtual camera within the computer to shoot the scene as a film (p. 50). "My works are not 'about' the place to which they refer in the way that either a documentary or a fictional film might be about them," Burgin remarks. "I have characterized my relationship to the object of my interest as a 'kind of psychical cubism'."[22] Here, the distinction between "taking" and "making" photographic images has all but collapsed.

Compiling an infinite number of photographs of the same subject or scene, and stitching them together into an interactive 3D platform, is yet another digital methodology; one that is at the root of Microsoft's Photosynth. According to its website, "Creating a synth allows you to share the places and things you love using the cinematic quality of a movie, the control of a video game, and the mind-blowing detail of the real world."[23] The language here emphasizes the user's capacity to shape and control a domain that is both open-ended and tailor made to the individual. In little over a century, we have come a long way

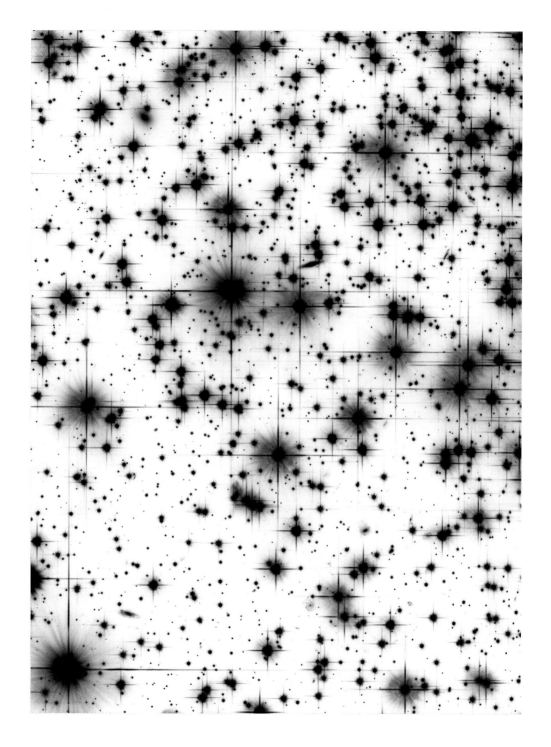

MUNGO THOMSON

AMERICAN, BORN 1969

Negative Space (STScl-PRC2006-37b), 2006.
Photographic mural, dimensions variable

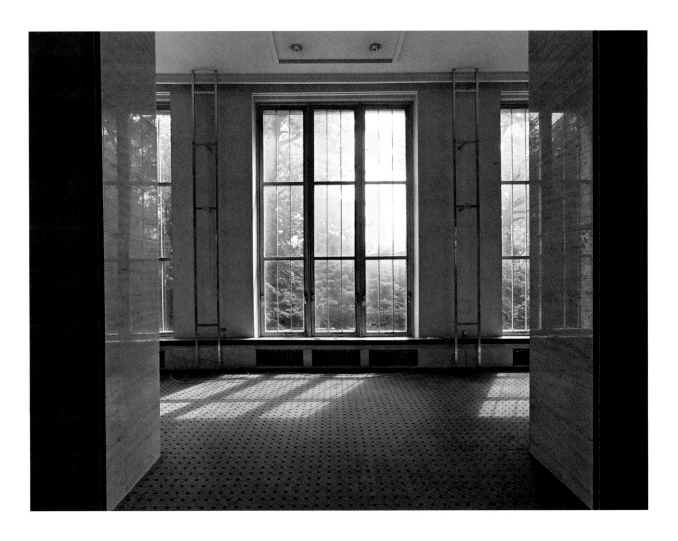

VICTOR BURGIN

BRITISH, BORN 1941

Still from *Hôtel Berlin*, 2009.
Digital photographic projection,
dimensions variable

from Kodak's promise to weekend snap shooters and amateur photographers, "You push the button, we do the rest."

We have also returned—via the work of two contemporary artists—to the view out a window in 1826 that marks a seismic shift in the history of visual imaging. Joan Fontcuberta constructs a photo mosaic of Joseph Nicéphore Niépce's study out of 10,000 pictures found on the Internet using Google's Image Search function responding to the word "photo" in English, French, and Spanish (pp. 78–79). Andreas Müller-Pohle constructs a code-based image that digitizes and translates into alphanumeric signs photography's earliest known photograph (p. 138). Neither image looks like what Niépce saw outside his window that day over 180 years ago, but both bear witness to the occasion, and translate it into a contemporary form of visual communication. Several questions are posed by these images, and by digital photography as a whole. Are we encountering a new language or a dialect? Are digitized photographs offshoots of a long-standing medium? Or are they indicative of an entirely new pictorial domain?

■ IS IT REAL? DOES IT MATTER?

When photography was introduced in the 1800s, some felt this machine-mediated rendering of the physical world would impoverish the arts. That same spirit of skepticism is alive today concerning computer imaging's impact, not just on analog photography, but on our visual consciousness as a whole. To some, the glut of photographic images facilitated by digitization, represents a mind-numbing noise that risks infecting us all with rampant voyeurism and image apathy. To others, the open access to photography and to new audiences that computer technology affords has spawned a liberating transparency that breaks down barriers between people, places, and ways of being.

One thing is certain: photographs no longer merely describe our world. In their all-pervasiveness, they now occupy our universe and fill our psyches.[24] We may know that there is no such thing as an unmediated record of an event: for every photograph, someone chooses a camera, a subject, a moment of exposure, and a point of view. But our belief in photography's relationship to the

real continues to color how we experience photographic images, digital and analog. In this regard, digital photography is both distinct from and embedded in the history of photography as we know it today.

At the same time, digital technology calls upon us to rethink previous arguments or ideas about what a camera does and how photographic images function in contemporary culture. It allows us to consider reality as mutable, not fixed, and to think of space and time as fluid, not static. It may be time to suspend questions about whether photographic art of any kind—analog or digital—is representative of the real. Perhaps future historians and anthropologists will look back on the history of photography and find that there was a finite period—roughly 150 years—when objectivity in visual record making was held dear. In the meantime, photographic artists will continue to make works that challenge our beliefs and change our experience of the world. Much as the advent of the hand-held camera and half-tone reproduction process at the end of the nineteenth century generated new attitudes and new art, the digital revolution promises to spawn ideas and visions of our universe that we cannot yet imagine.

Endnotes

1. Of the two images attributed to Niépce, one is a reproduction of the original photographic plate, and the other is an image Kodak produced from the plate in 1952, which was modified by Helmut Gernsheim to correct imperfections. This second image is how we have known the plate until 2002, when it went to the Getty Conservation Institute to be digitally photographed. See http://www.hrc.utexas.edu/exhibition/permanent/wfp

2. See Lev Manovich, *The Language of New Media* (Cambridge: MIT Press, 2001) pp. 21–22

3. See Alain Renaud's "From Photography to Photology" in *Art/Photographie Numérique:Art/Digital Photography* (Cypres, École d'Art d'Aix-en-Provence), p. 180

4. See Christiane Paul, *Digital Art* (London: Thames & Hudson Ltd. 2008), pp. 8–11

5. See Corona page at National Reconnaissance Office (http://nro.gov/corona/facts.html) and at NASA (http://samadhi. jpl.nasa.gov/msl/Programs/coronoa.html)

6. Fred Ritchin, *After Photography* (New York: W. W. Norton & Company, 2009), pp. 27-28

7. André Bazin, "The Ontology of the Photographic Image" in Alan Trachtenberg (ed.) *Classic Essays on Photography* (New Haven, CT: Leete's Island Books, 1981), p. 242.

8. Roland Barthes, *Camera Lucida*, trans. Richard Howard (New York: Hill and Wang, 1981), p. 77

9. One of the key figures in postmodernism, Richard Prince, manipulated digital imagery on the computer as part of his day job in advertising. See Manovich, p. 142.

10. See "Early Composites" at http://www.nancyburson.com.

11. Esther Parada, "Taking Liberties: Digital Revision as Cultural Dialogue," in *Leonardo*, Vol. 26, No. 5 (International Society for the Arts, Sciences, and Technology, 1993), pp. 445–450

12. The artist in conversation with the author, September 2009.

13. From the transcript of Viral Landscapes, a podcast of a talk given in December 2006 at Walker Art Gallery by Curator of Fine Art, Ann Bukantas. See http://www.liverpoolmuseums.org.uk/podcasts/transcripts/viral_landscapes.asp

14. Helen Chadwick in *Enfleshings: Helen Chadwick* (New York, Aperture 1989), p. 109

15. See http://www.collectedvisions.net.

16. See http://www.akakurdistan.net.

17. Paul Berger, from an artist's statement for "Warp & Weft Series," 2000–2002.

18. The artist, in conversation with the author, September, 2009. McMakin attributes the variation in color of the prints as due to some unexplained element in the camera; "a ghost in the machine."

19. The artists in correspondence with the author, September 2009.

20. http://whitelead.com. Haddock also notes that copyright for this image, from the Zapruder film of the assassination of John F. Kennedy, was held by *Time Magazine*. When a publishing house used it in a history book, the publisher was sued. When brought to trial, the court's decision held that facts are different from ideas in copyright: because this film contained facts, its imagery could be used in the history book for free.

21. To learn more about the process by which Hubble imagery goes public, see http://www.pbs.org/wgbh/nova/ sciencenow/0303/01-howi-flash.html.

22. Victor Burgin, from a text written for the exhibition "Hôtel Berlin," at Galerie Campagne Première, Berlin, September 22–November 7, 2009.

23. http://photosynth.net/about.aspx

24. This idea comes from Paul Berger, shared in conversation with the author.

Plates

ALEXANDER APOSTOL
VENEZUELAN, BORN 1969

Plaza Venezuela, 2003. From the series *Fontainebleau*.
Digital photograph, 49 ¼ x 49 ¼ in. (125 x 125 cm)

(opposite) *Rosenthal*, 2001. From the series *Residente Pulido*.
Digital photograph, 78 ¾ x 59 in. (200 x 150 cm)

AZIZ + CUCHER

ANTHONY AZIZ, AMERICAN, BORN 1961 / SAMMY CUCHER, VENEZUELAN, BORN 1958

Burnt Mountain, 2007.
Chromogenic color print on Endura metallic paper,
50 x 72 in. (127 x 182.88 cm)

(opposite) *Interior #1*, 1999.
Chromogenic color print, 68 x 48 in.
(172.72 x 121.92 cm)

PAUL BERGER

AMERICAN, BORN 1948

PanCam-006, 2008.
Pigmented inkjet print, 34 x 52 in.
(86.4 x 147.3 cm)

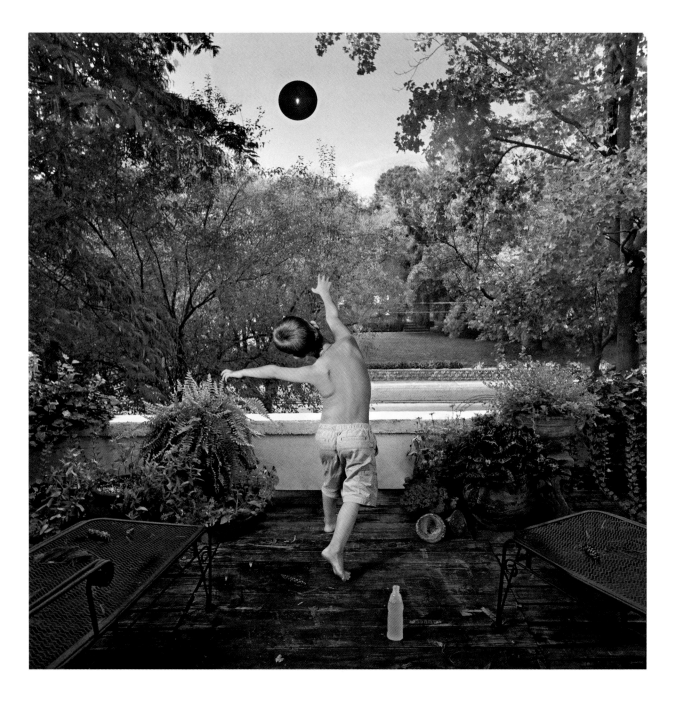

JULIE BLACKMON

AMERICAN, BORN 1966

Powerade, 2005. From the series *Domestic Vacations*.
Pigmented inkjet print, 22 x 22 in. (55.9 x 55.9 cm)

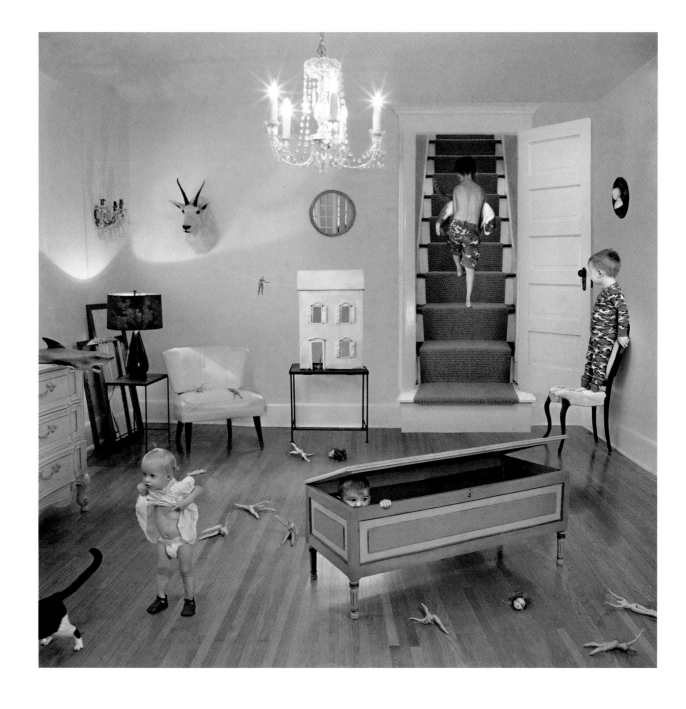

Camouflage, 2005. From the series *Domestic Vacations*.
Pigmented inkjet print, 22 x 22 in. (55.9 x 55.9 cm)

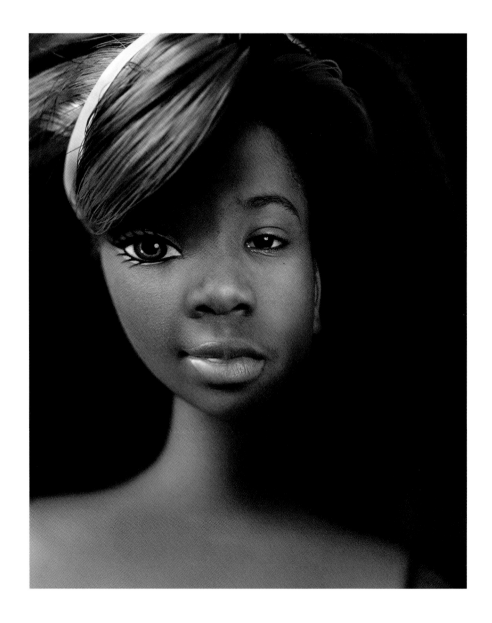

SHEILA PREE BRIGHT
AMERICAN, BORN 1967

Untitled, #2, 2003. From the series *Plastic Bodies*.
Chromogenic color print, 30 x 24 in. (76.2 x 60.96 cm)

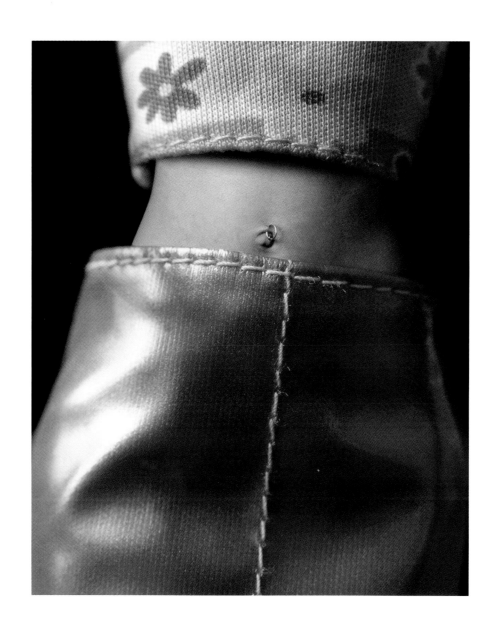

Untitled, #15, 2003. From the series *Plastic Bodies*.
Chromogenic color print, 30 x 24 in. (76.2 x 60.96 cm)

NANCY BURSON

AMERICAN, BORN 1948

First and Second Beauty Composites
(Left: Bette Davis, Audrey Hepburn, Grace Kelly, Sophia Loren, Marilyn Monroe.
Right: Jane Fonda, Jacqueline Bisset, Diane Keaton, Brooke Shields, Meryl Streep), 1982.
Two gelatin silver prints from computer-generated images,
7 ¼ x 8 ¼ in. (18.39 x 20.95 cm) each

Mankind (Oriental, Caucasian & Black
weighted according to current population statistics), 1983–85.
Gelatin silver print from computer-generated image,
14 x 11 in. (35.56 x 27.94 cm)

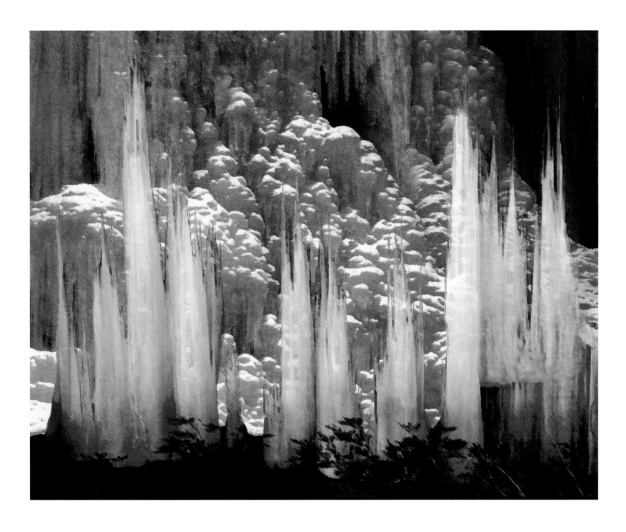

PETER CAMPUS

AMERICAN, BORN 1937

Fire/Ice, 1992.
Pigmented inkjet print, 6 ⅞ x 8 ⁹⁄₁₆ in.
(17.5 x 21.8 cm)

(opposite) *Decay*, 1991.
Pigmented inkjet print, 23 x 18 ½ in.
(58.42 x 46.99 cm)

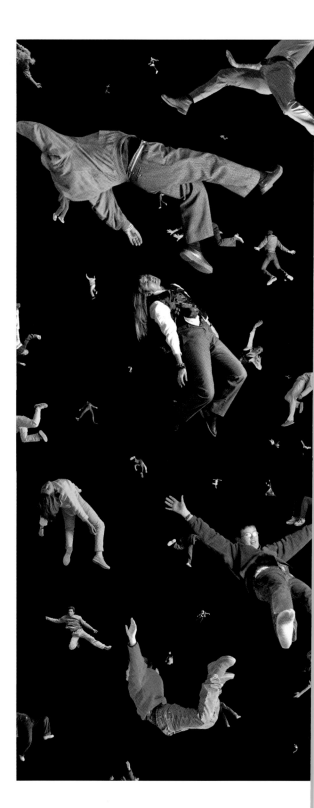

DANIEL CANOGAR
SPANISH, BORN 1964

Horror Vacui, 1999.
Digital wallpaper, dimensions variable

(pp. 16–17) *Gravedad Cero 2*, 2002.
Cibachrome print, 47 x 66 in.
(119.5 x 167.5 cm)

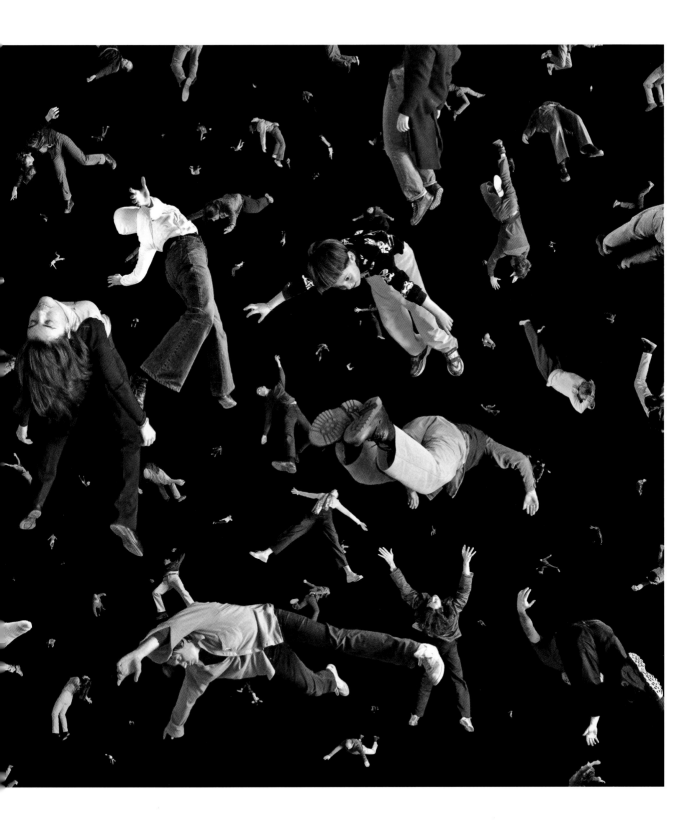

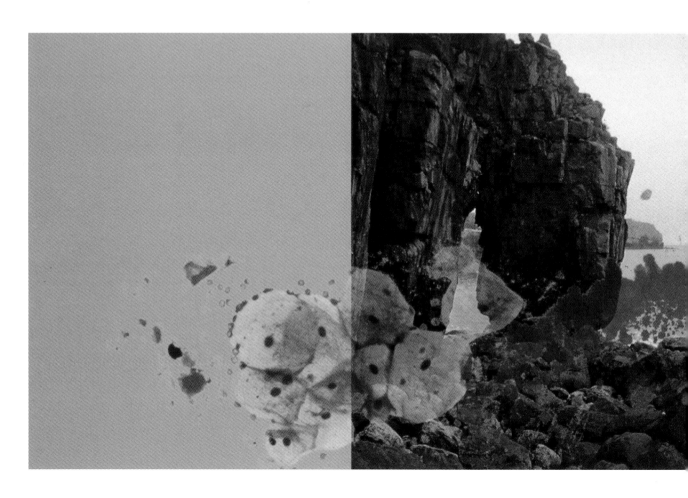

HELEN CHADWICK
BRITISH, 1953–1996

Landscape No. 1, from the series *Viral Landscapes*, 1988–89.
Chromogenic color print from Cromalin proof,
48 x 120 in. (120 x 300 cm)

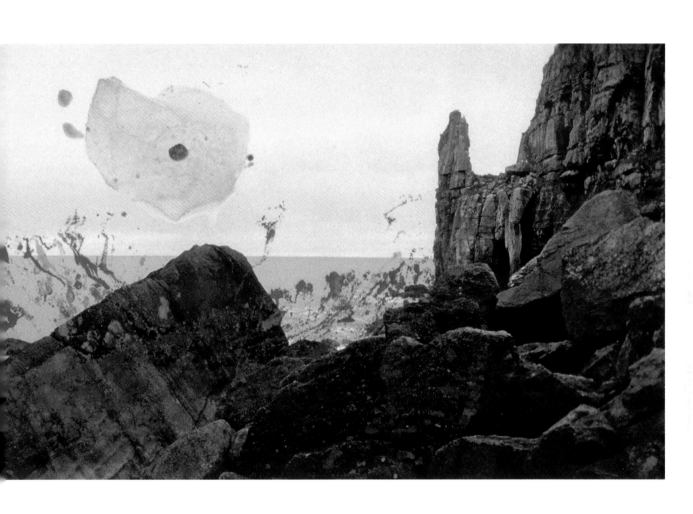

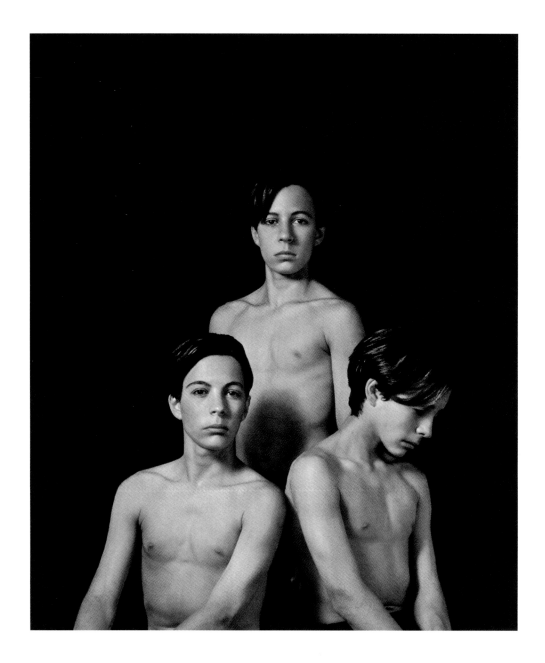

KEITH COTTINGHAM
AMERICAN, BORN 1965

Fictitious Portrait (Triple), 1993.
Constructed photograph, chromogenic color print,
46 x 38 in. (116.84 x 96.52 cm)

(opposite) *Untitled*, 2004.
Constructed photograph, chromogenic color print,
66 ¾ x 48 in. (169.55 x 121.92 cm)

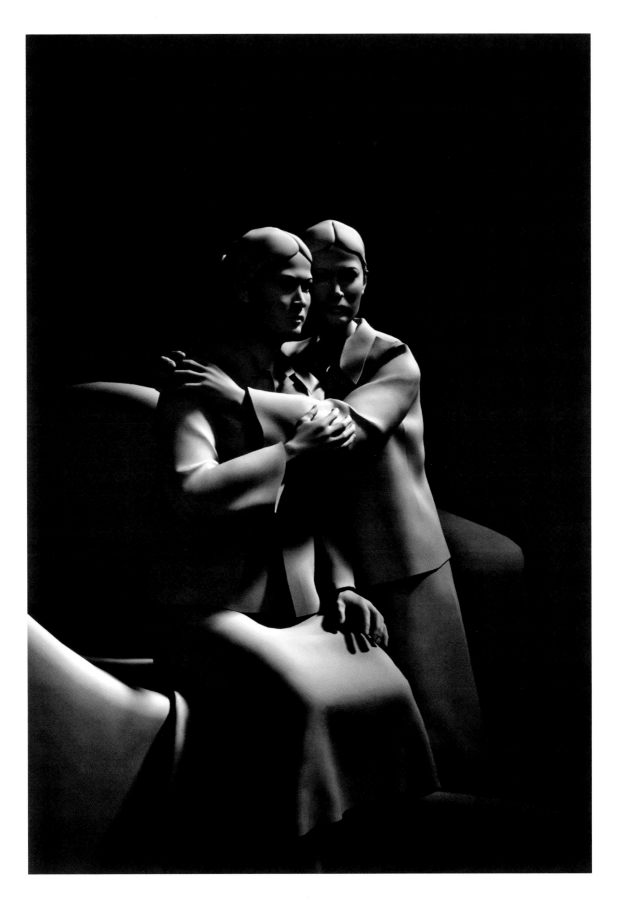

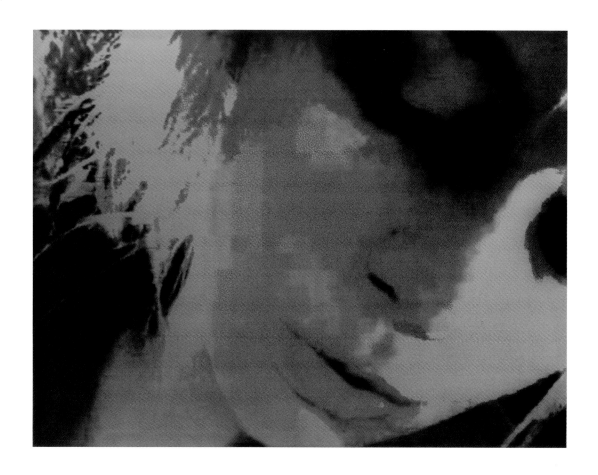

SEAN DACK

AMERICAN, BORN 1976

Untitled #9, 2005.
Chromogenic color print, 25 ⅝ x 33 ½ in.
(65.1 x 85.1 cm)

Unmarked CIA Airplane, 2008.
Chromogenic color print, 30 x 44 ⅝ in.
(76.2 x 113.35 cm)

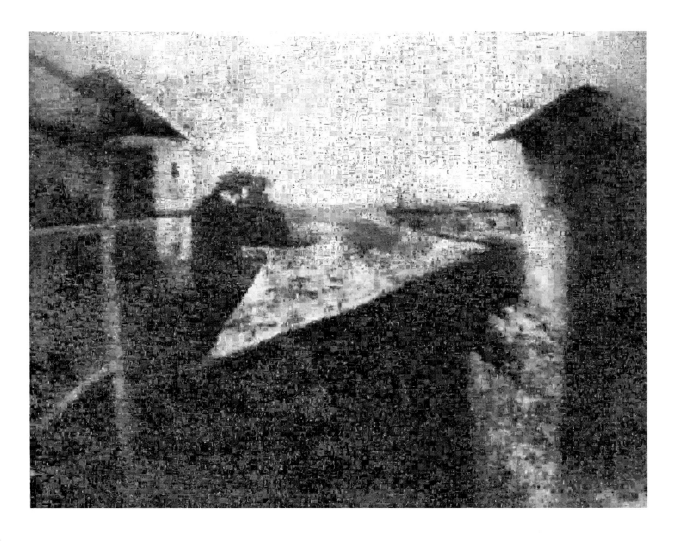

JOAN FONTCUBERTA
SPANISH, BORN 1955

Googlegram: Niépce, 2005.
Type-C print, 47 ¼ x 63 in. (120 x 160 cm)
(detail, opposite)

———

First photograph in history, taken by Nicéphore Niépce
in Gras, France, 1826. The photograph has been refashioned
using photomosaic freeware linked to Google's Image Search function.
The final result is a composite of 10,000 images available on
the Internet that responded to the words "photo"
and "foto" as search criteria.

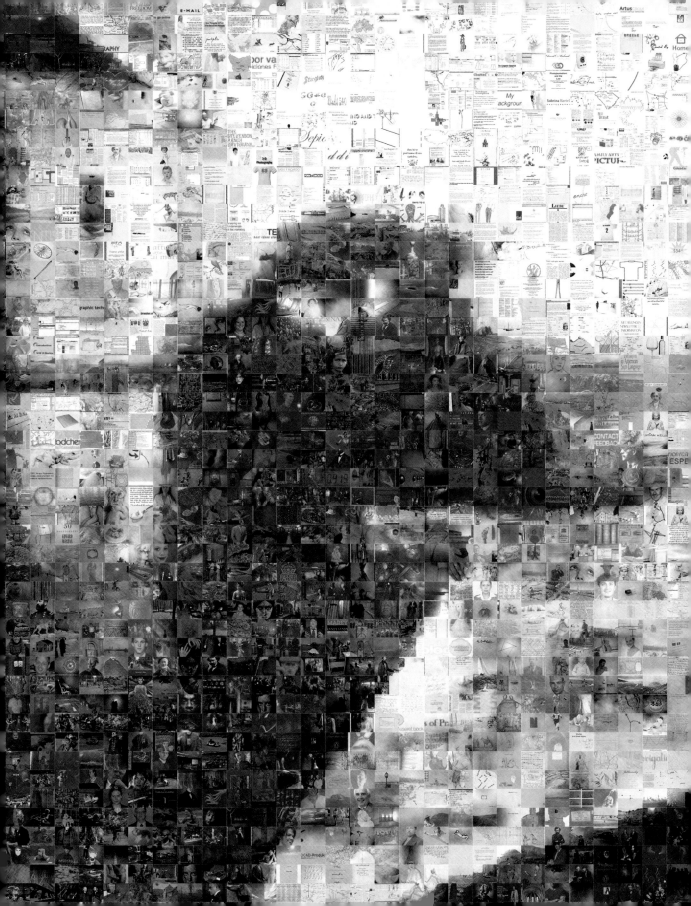

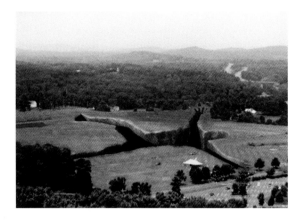

AMERICAN, BORN 1965

Untitled, 1998.
Lambda print, 24 ¼ x 46 in.
(61.6 x 116.8 cm)

(opposite) *Untitled*, 1996.
Chromogenic color print, 3 x 4 ⅜ in.
(7.5 x 11 cm)

NORIKO FURUNISHI

JAPANESE, BORN 1966

Untitled (waterfall), 2007.
Chromogenic color print,
93 ½ x 48 in. (237.5 x 121.9 cm)

(opposite) *Ice Park (A)*, 2007.
Chromogenic color print,
89 ¼ x 60 in. (226.7 x 152.4 cm)

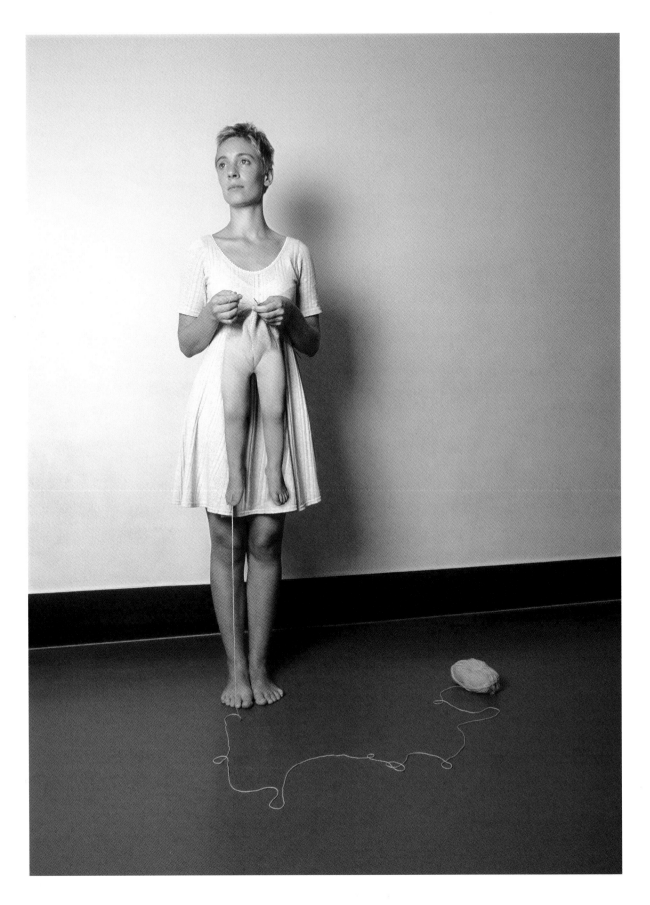

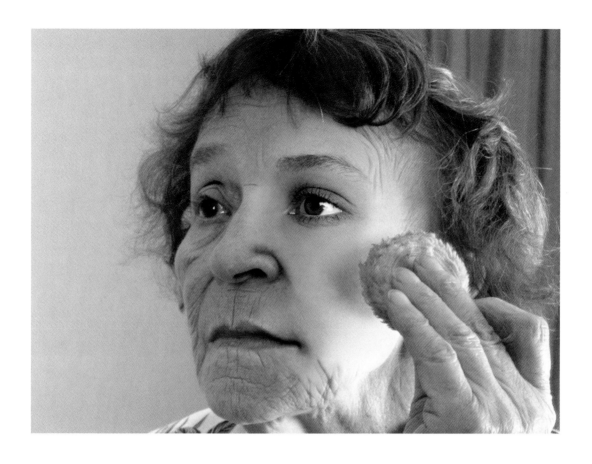

MARGI GEERLINKS

DUTCH, BORN 1970

Untitled, 2000.
Cibachrome mounted to Plexiglas on Dibond,
26 x 36 in. (66.04 x 91.44 cm)

(opposite) *Untitled*, 1997–98.
Cibachrome mounted to Plexiglas on Dibond,
39 x 29 in. (99.06 x 73.66 cm)

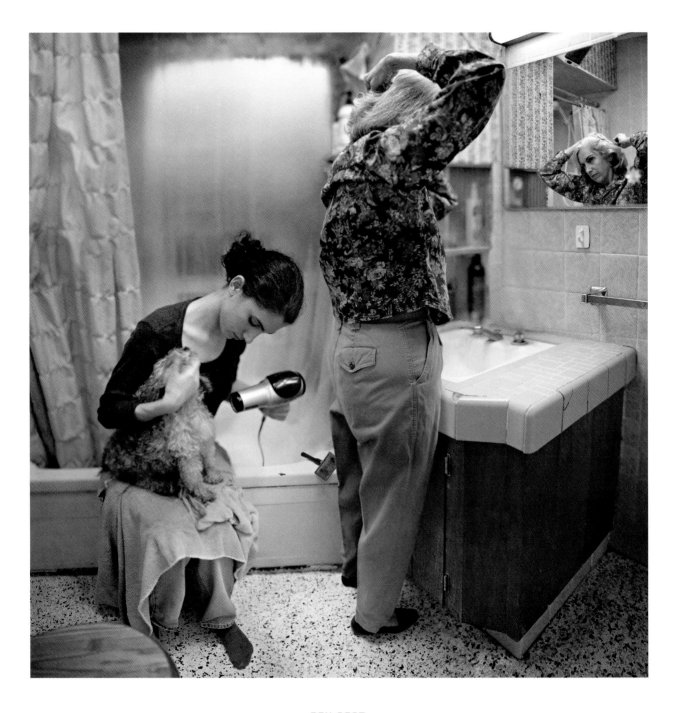

BEN GEST

AMERICAN, BORN 1975

Sam and Jessica, 2002.
Pigmented inkjet print, 40 x 41 in.
(101.6 x 104.1 cm)

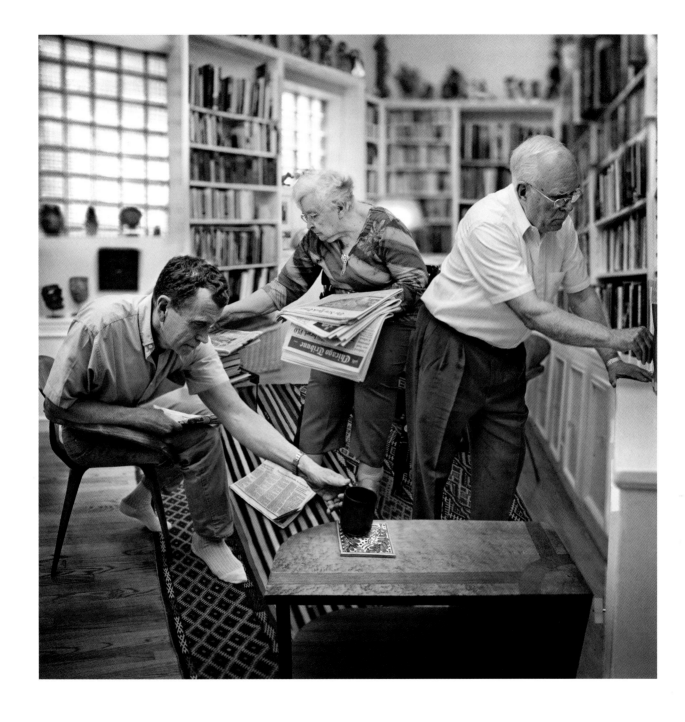

Chuck, Alice, and Dale, 2003.
Pigmented inkjet print, 40 x 41 in.
(101.6 x 104.1 cm)

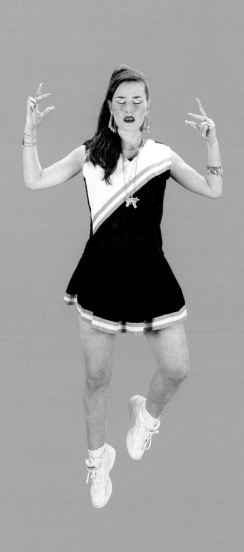

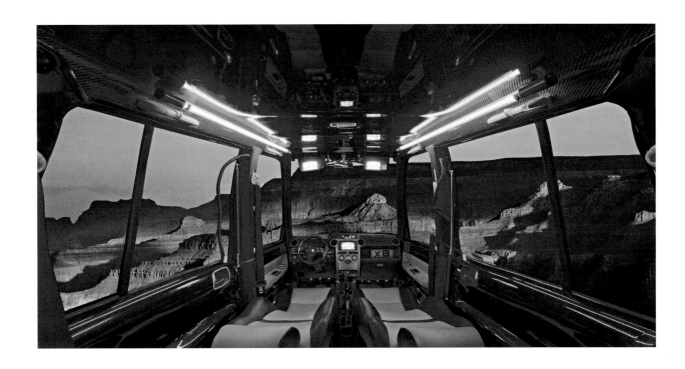

LUIS GISPERT

AMERICAN, 1972

You're My Favorite Kind of American, 2008.
From the series *You're My Favorite Kind of American*.
Chromogenic color print, 72 x 110 in.
(182.8 x 279.4 cm)

(opposite) *Hoochy Goddess*, 2001.
From the series *Cheerleaders*.
Chromogenic color print, 72 x 40 in.
(28.35 x 15.75 cm)

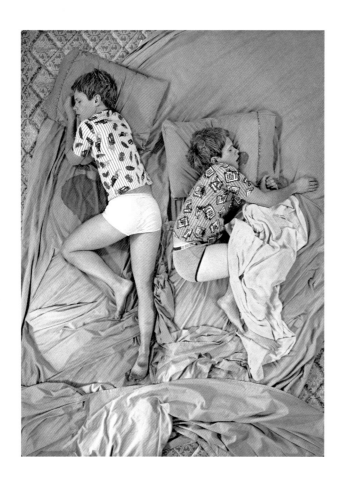

ANTHONY GOICOLEA
AMERICAN, BORN 1971

Bedwetters, 2000.
Digital black & white print, 55 x 40 in.
(139.7 x 101.6 cm)

Tree Dwellers, 2005.
Chromogenic color print, 72 x 98 in.
(182.9 x 248.9 cm)

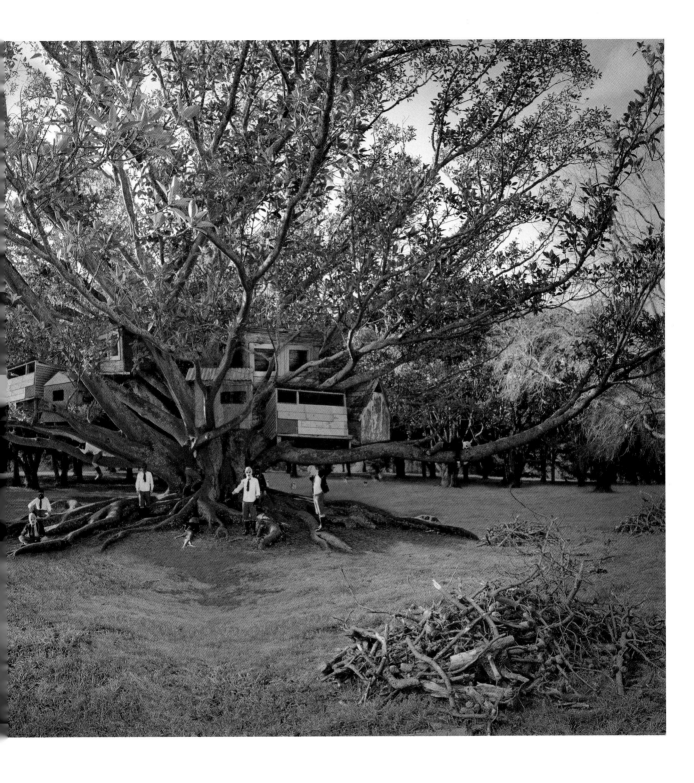

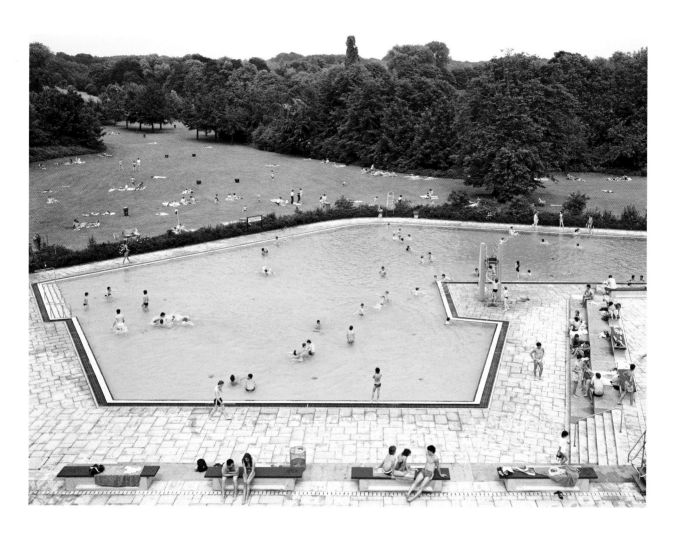

ANDREAS GURSKY

GERMAN, BORN 1955

Swimming Pool, Ratingen, 1987.
Chromogenic color print, 42 x 51 in.
(106.7 x 129.5 cm)

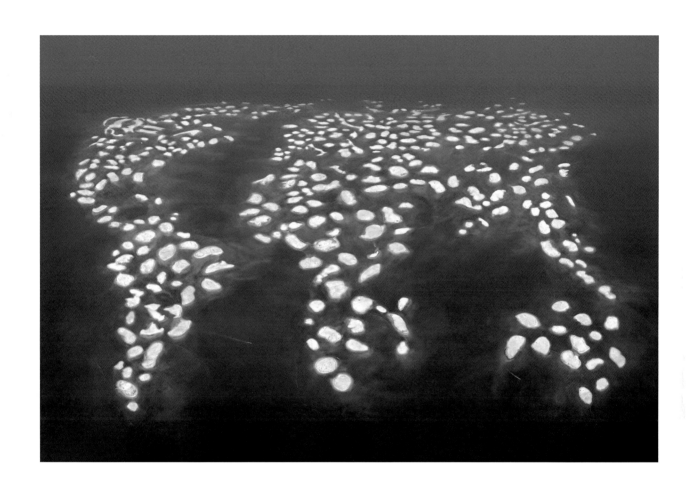

Dubai World III, 2008.
Chromogenic color print, 93.3 x 134.8 x 2.4 in.
(237 x 342.5 x 6.2 cm)

JON HADDOCK

AMERICAN, BORN 1960

Children Fleeing Napalm Strike, Modified—1972,
Huynk Cong "Nick" Ut, 2000.
Digital image,
dimensions variable

Time Inc. v. Bernard Geis Associates,
293 F.Supp.130 (S.D.N.Y. 1968), 2003.
Digital image,
dimensions variable

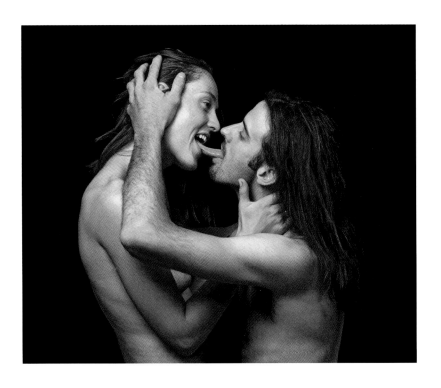

DIETER HUBER
AUSTRIAN, BORN 1962

Klone #92, 1997.
Computer work, Diasec/aluminum,
59 x 70 ⅞ in. (150 x 180 cm)

airborn33 Đ Minus Zero, 2006.
Computer aided painting on canvas/Alustretch,
65 x 126 in. (165 x 320 cm)

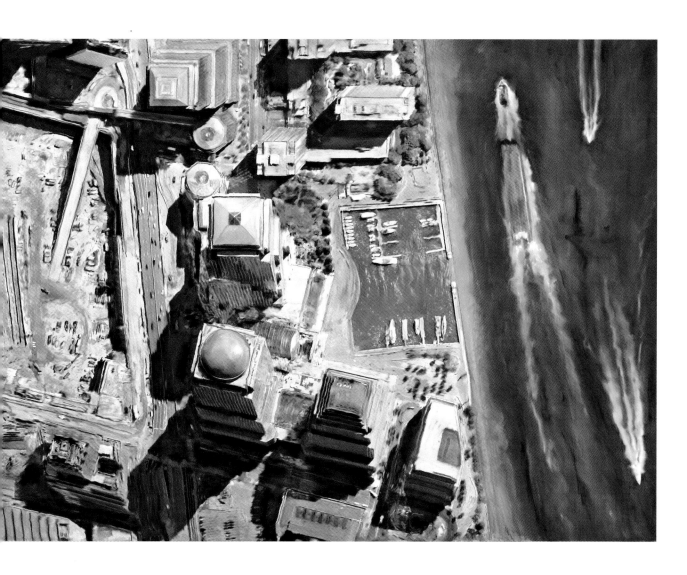

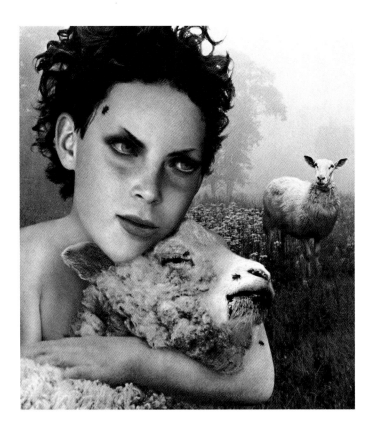

SIMEN JOHAN
NORWEGIAN, BORN 1973

Untitled, #65, 1997.
From the series *And Nothing Was to be Trusted*.
Gelatin silver print, 19 x 19 in.
(48.26 x 48.26 cm)

(opposite) *Untitled, #153*, 2008.
From the series *Until the Kingdom Comes*.
Chromogenic color print, 71 x 103 ½ in.
(180.34 x 262.89 cm)

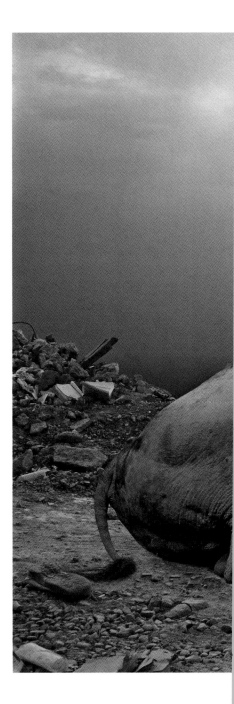

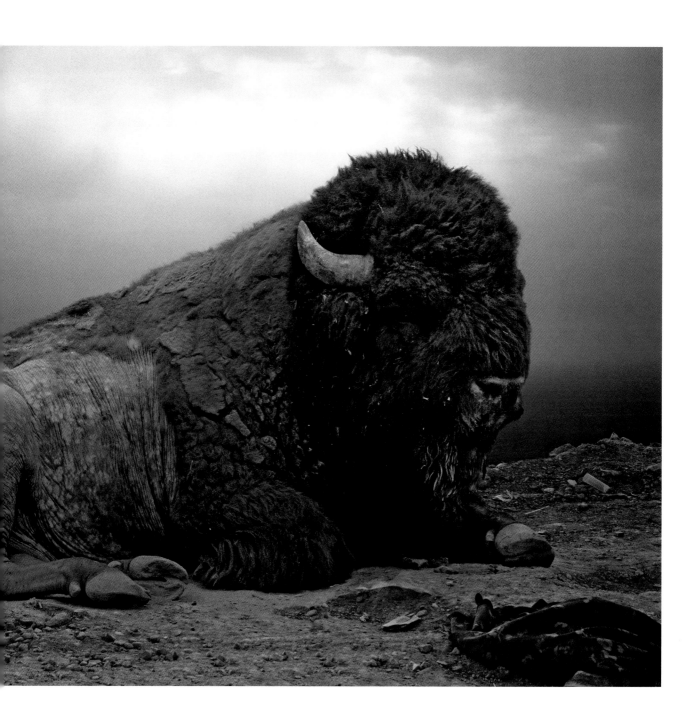

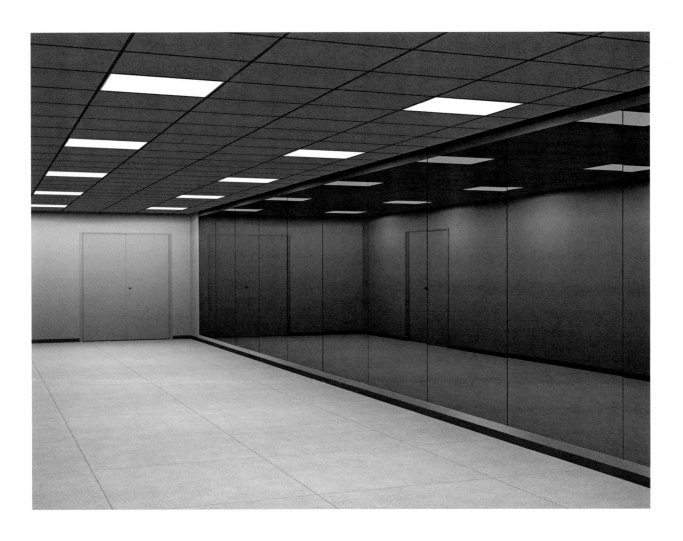

CRAIG KALPAKJIAN

AMERICAN, BORN 1961

Lobby, 1996.
Silver dye bleach print (Ilfochrome)
mounted to Plexiglas on aluminum, 29 ¼ x 39 ¼ in.
(74.3 x 99.7 cm)

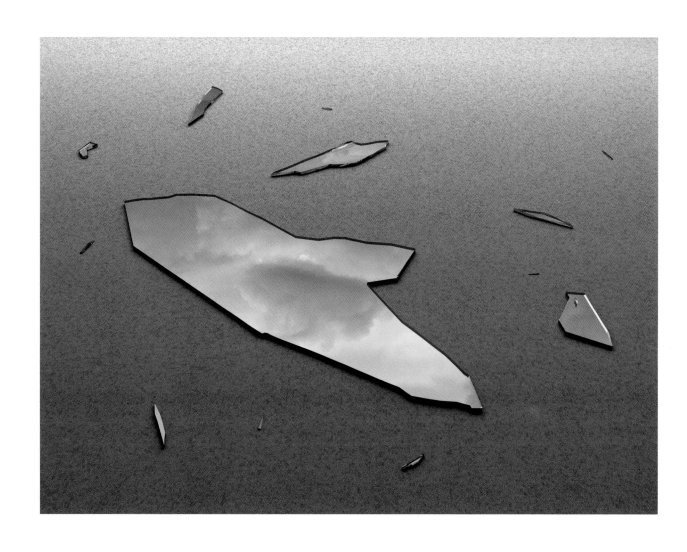

Shard, 2007.
Pigmented inkjet print, 32 x 43 in.
(81.3 x 109.2 cm)

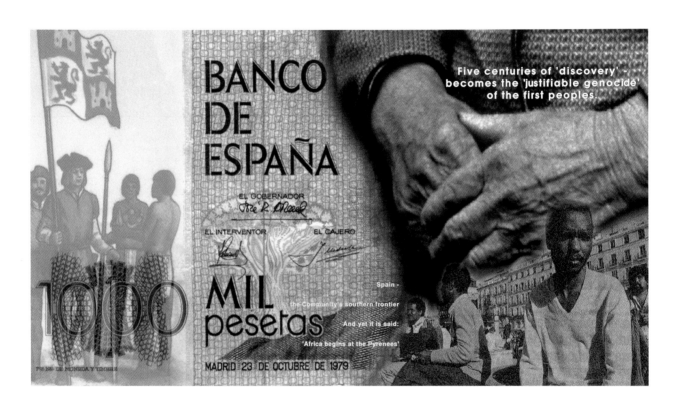

ROSHINI KEMPADOO

BRITISH, BORN 1959

ECU: European Currency Unfolds, mil pesetas, 1992.
Chromogenic color print, 23 ⅝ x 41 in.
(60 x 104 cm)

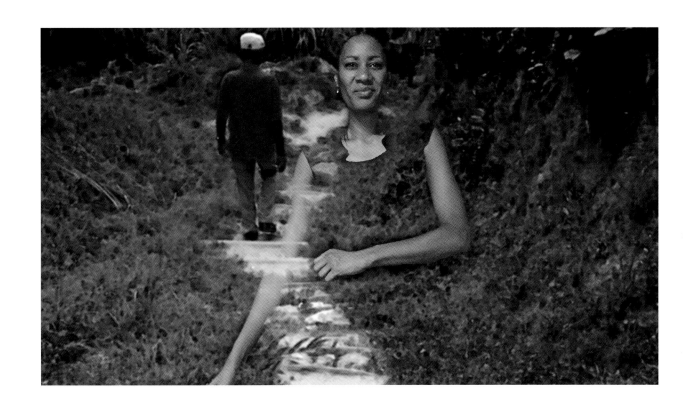

Amendments 08, 2007.
Pigmented inkjet print, 23 ⅝ x 13 ¼ in.
(60 x 33.75 cm)

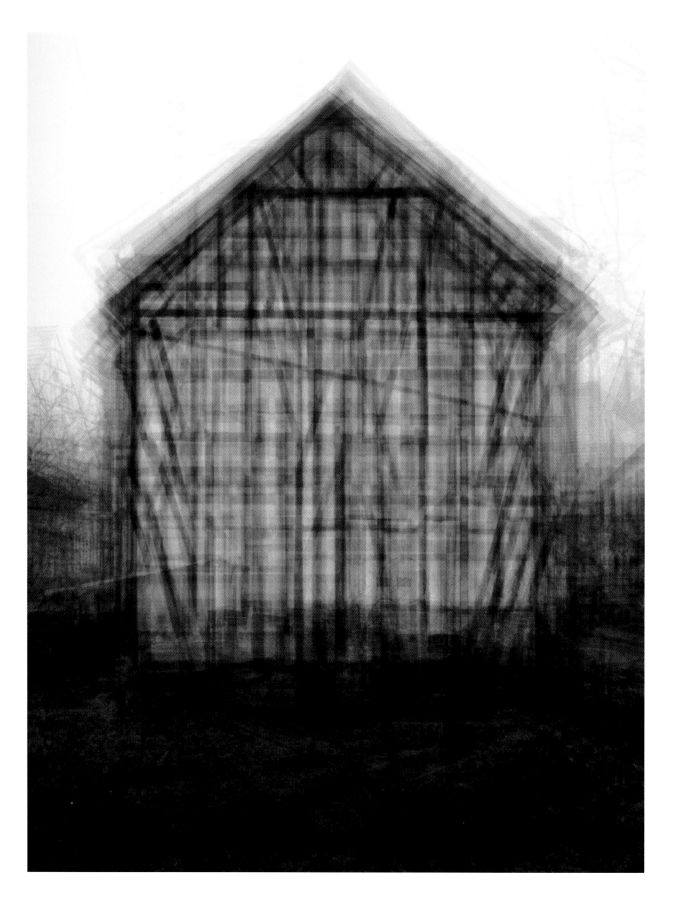

IDRIS KHAN

BRITISH, BORN 1978

1 Book, 4 Sides, 2 Directions, 2009.
Digital bromide print, 46 x 38 in.
(116.8 x 96.5 cm)

(opposite) *Every Bernd and Hilla Becher
Gable Side House*, 2004.
Chromogenic color print, 82 x 63 in.
(208 x 160 cm)

BRANDON LATTU

AMERICAN, BORN 1970

Selected Products, 2001.
Pigmented inkjet print, 24 x 30 in.
(60.96 x 76.2 cm)

(opposite) *Library: Storage Boxes*, 2008.
Pigmented inkjet print, 55 x 73 ⅜ in.
(139.7 x 186.18 cm)

Sink, 2008.
Pigmented inkjet print, 58 x 78 ½ in.
(147.3 x 199.4 cm)

(opposite) *Cabinet*, 2009.
Chromogenic color print, 72 x 79 in.
(182.8 x 200.6 cm)

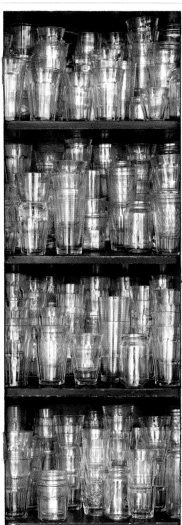
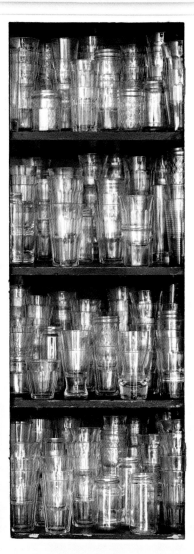

SHERRIE LEVINE
AMERICAN, BORN 1947

After Cézanne 5, 2007.
Pigmented inkjet print, 13 x 19 in.
(33 x 48.3 cm)

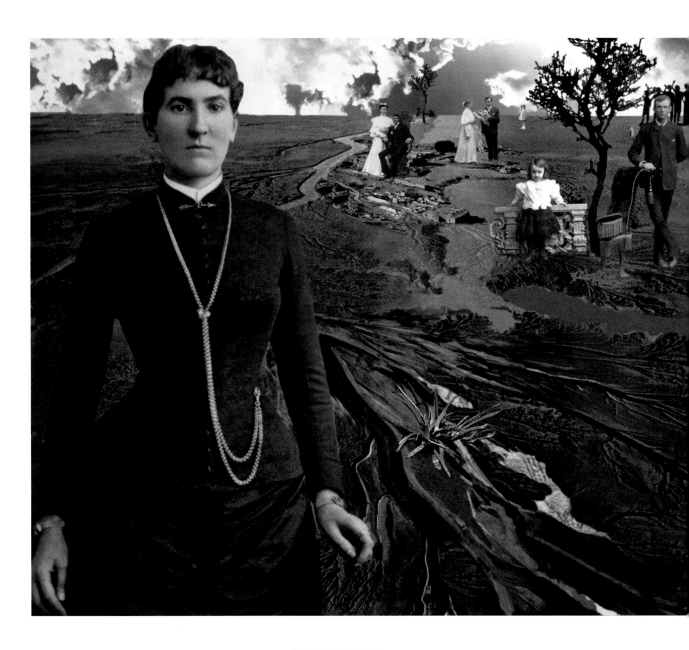

MARTINA LOPEZ

AMERICAN, BORN 1962

Heirs Come to Pass 3, 1991.
Silver dye bleach print from digital file,
30 x 50 in. (76.2 x 127 cm)

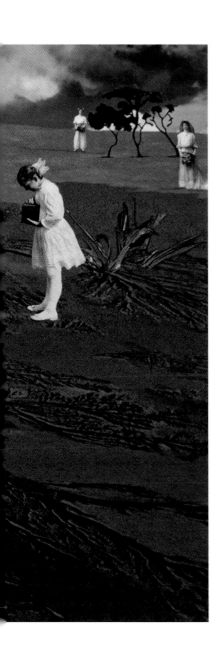

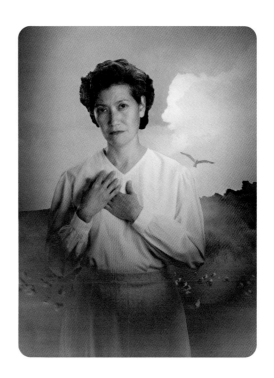

Remembrance, 1, 2009.
Ultrachrome print, 22 x 17 ½ in.
(55.9 x 44.4 cm)

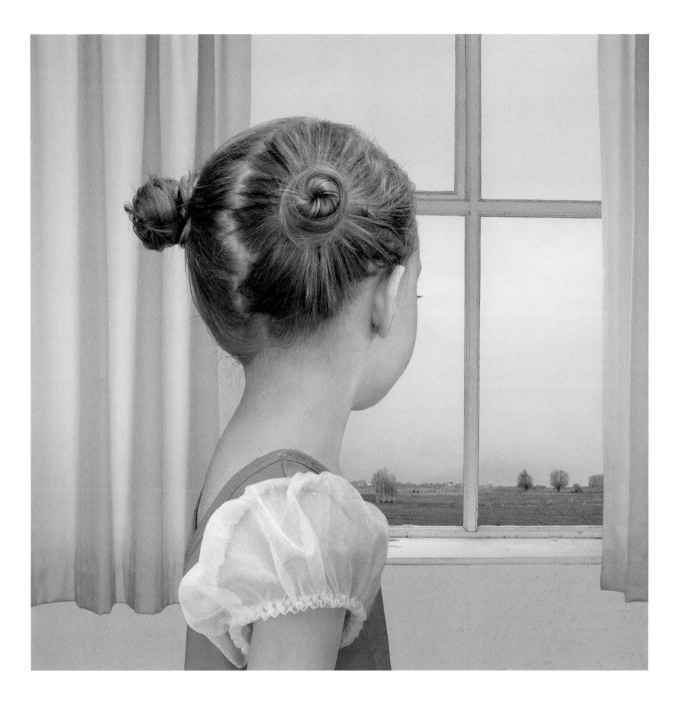

LORETTA LUX

GERMAN, BORN 1969

At the Window, 2004.
Ilfochrome print, 19 ⅝ x 19 ⅝ in.
(50 x 50 cm)

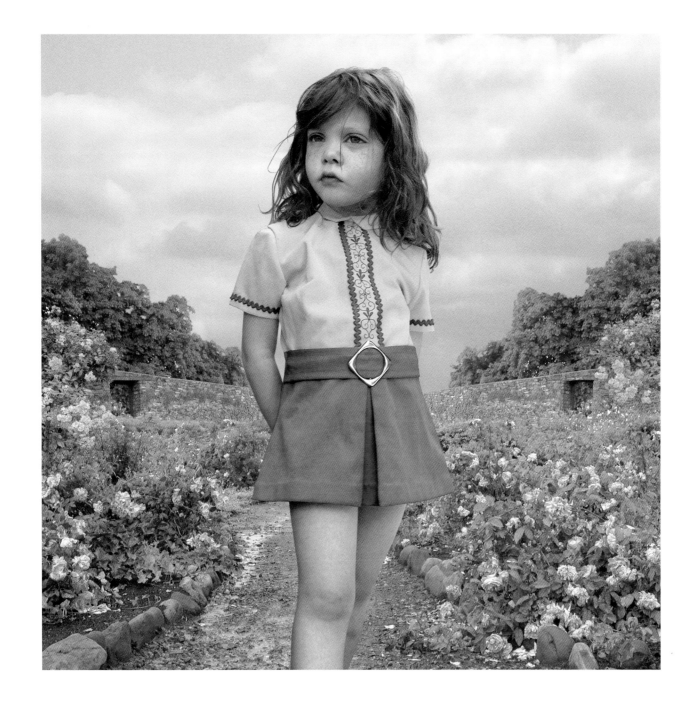

The Rose Garden, 2001.
Ilfochrome print, 19 ⅝ x 19 ⅝ in.
(50 x 50 cm)

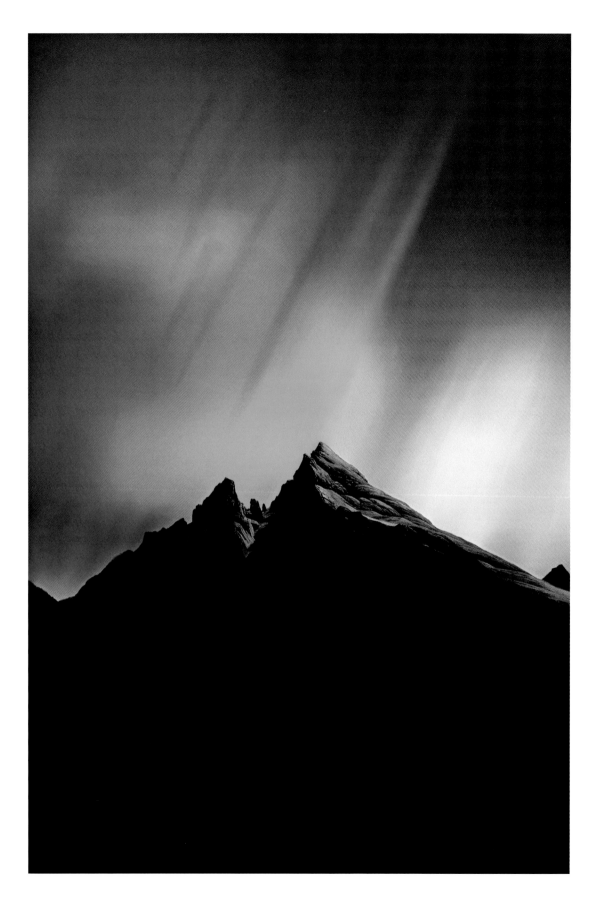

FLORIAN MAIER-AICHEN
GERMAN, BORN 1973

Untitled, 2009.
Chromogenic color print, 72 ⅛ x 90 ¾ in.
(183.2 x 230.5 cm)

(opposite) *Der Watzmann*, 2009.
Chromogenic color print, 84 ¼ x 60 ⅜ in.
(214 x 153.4 cm)

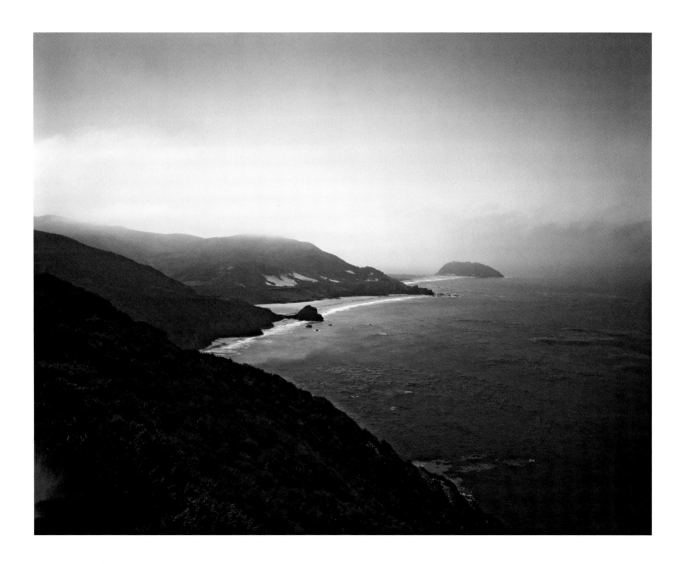

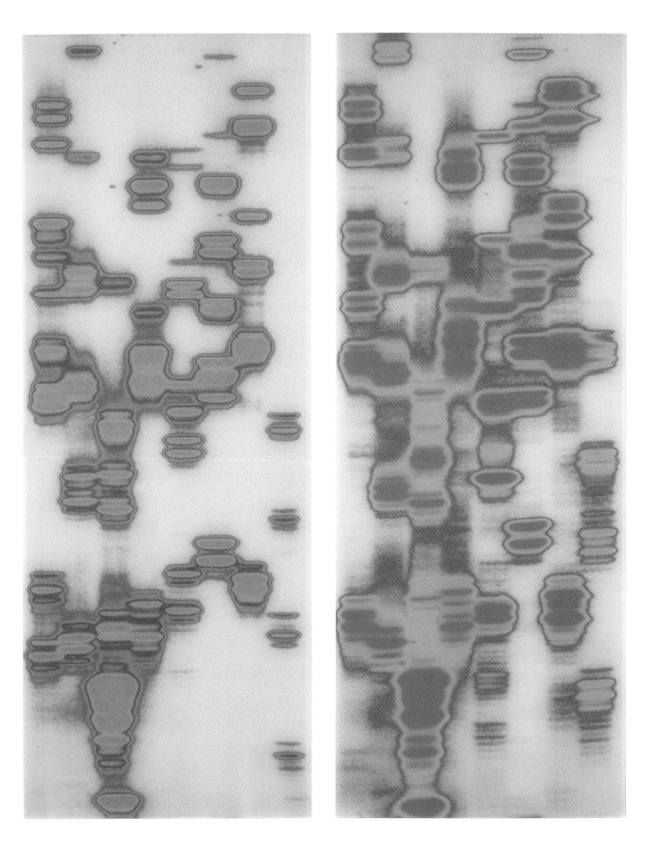

IÑIGO MANGLANO-OVALLE
AMERICAN, BORN 1961

Iñigo, Elvi, and Iñigo, 1998.
From the series *Garden of Delights*.
Three chromogenic color prints
mounted to Plexiglas on aluminum,
60 x 23 in. (152.3 x 58.3 cm) each

MANUAL

SUZANNE BLOOM, AMERICAN, BORN 1943 / ED HILL, AMERICAN, BORN 1935

Et in Arcadia Ego: Topology of the Pastoral, 1998.
Iris print, 47 x 35 in. (119.38 x 88.9 cm)

On the Verge: Chappell Hill, oak tree | audio track, 2006.
Archival pigment print, 43 x 34 ¾ in. (109.22 x 88.27 cm)

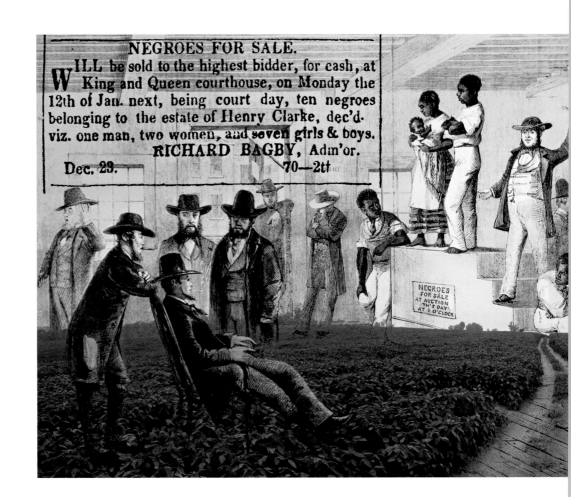

NEGROES FOR SALE.

WILL be sold to the highest bidder, for cash, at King and Queen courthouse, on Monday the 12th of Jan. next, being court day, ten negroes belonging to the estate of Henry Clarke, dec'd. viz. one man, two women, and seven girls & boys.

RICHARD BAGBY, Adm'or.

Dec. 23. 70—2tt

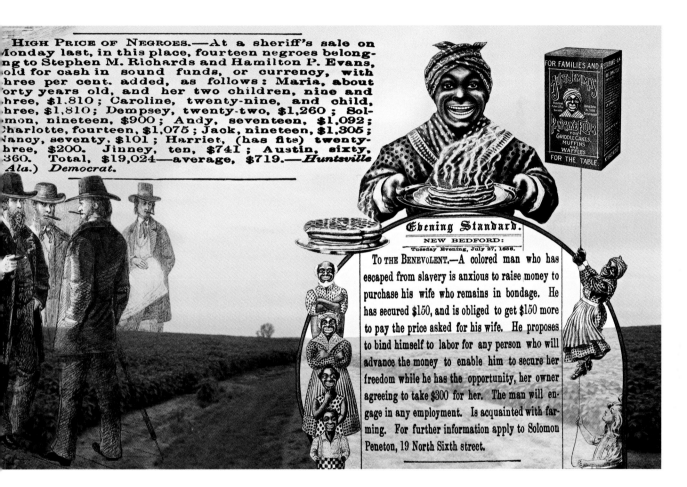

STEPHEN MARC

Untitled, 2007.
Pigmented inkjet print, 18 x 52 in.
(45.72 x 132.08 cm)

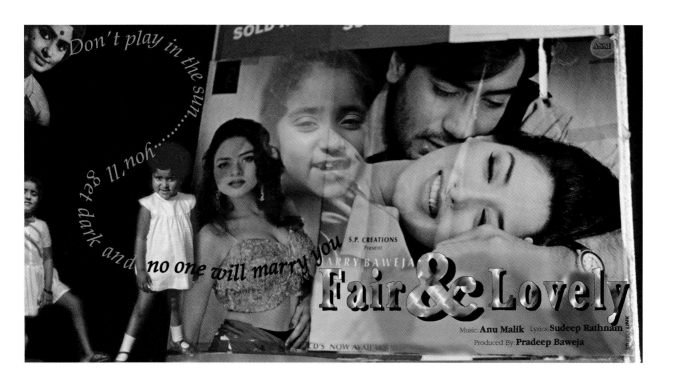

ANNU PALAKUNNATHU MATTHEW

BRITISH, AMERICAN, AND INDIAN, BORN 1964

Fair & Lovely, 1998.
From the series *Bollywood Satirized*.
Luminage digital print, 48 x 70 in.
(121.92 x 177.8 cm)

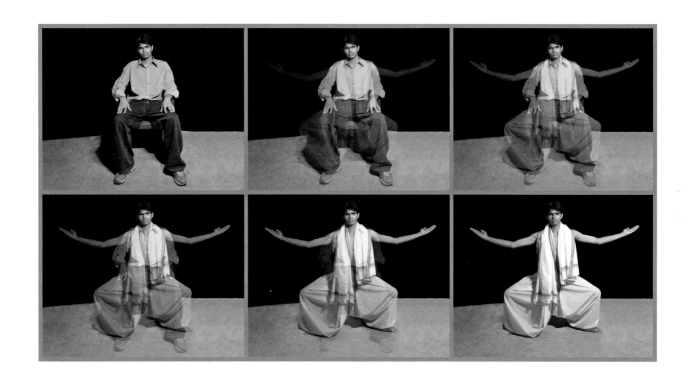

Anirudh, 2006.
From the series *The Virtual Immigrant*.
Sequel rendering of a lenticular print, 40 x 53 in.
(101.6 x 134.62 cm) each

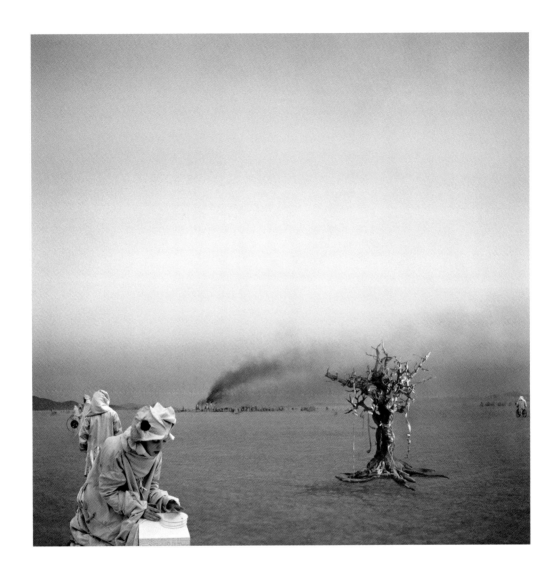

MARY MATTINGLY

AMERICAN, BORN 1978

Silent Engineers, 2005. From the series *Second Nature*.
Chromogenic color print, 30 x 30 in.
(76.2 x 76.2 cm)

(opposite) *Kart*, 2008. From the series *Nomadographies*.
Chromogenic color print, 40 x 40 in.
(101.6 x 101.6 cm)

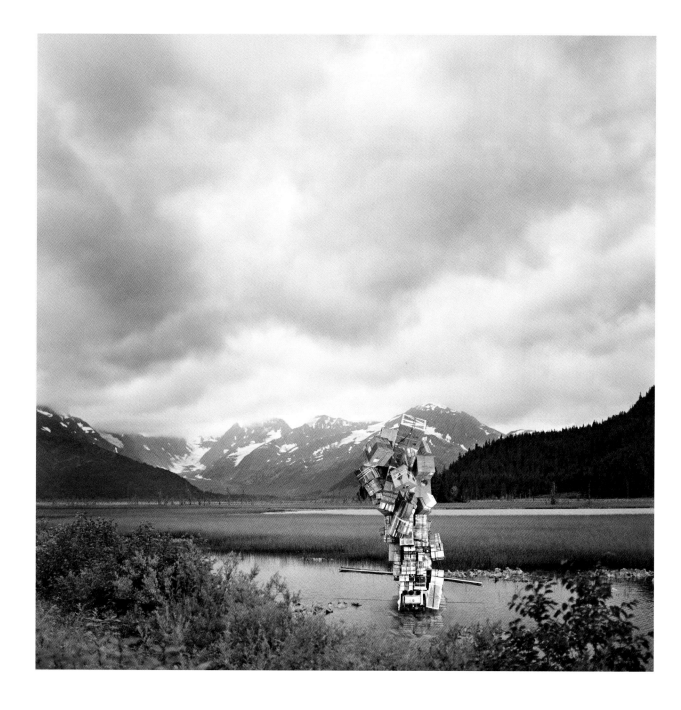

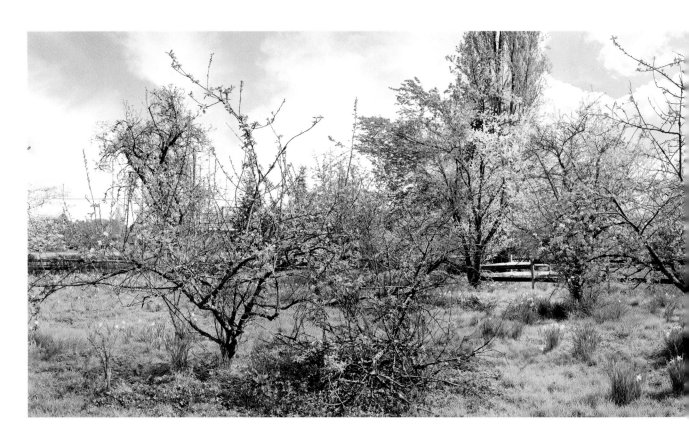

SCOTT McFARLAND

CANADIAN, BORN 1975

Orchard on Dr. Young's Property, 3226 W. 51 St.,
Vancouver, 2005. Pigmented inkjet print,
40 ⅛ x 120 ⅛ in. (102 x 305 cm)

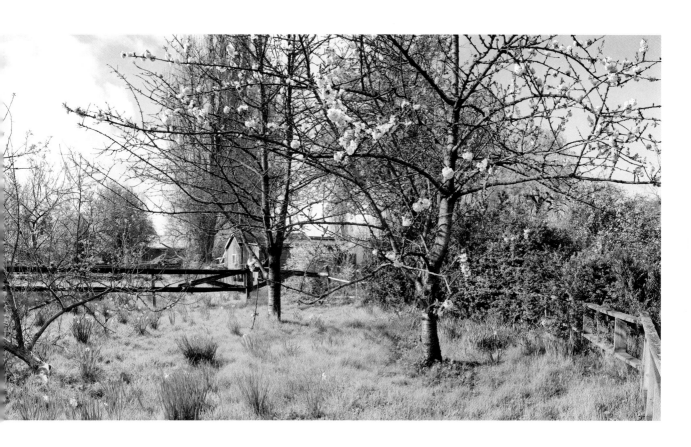

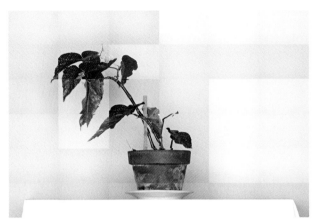
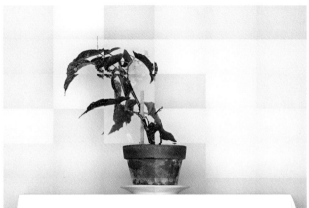
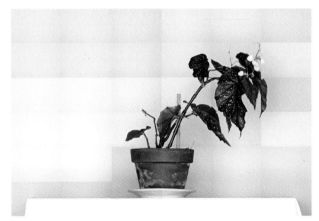
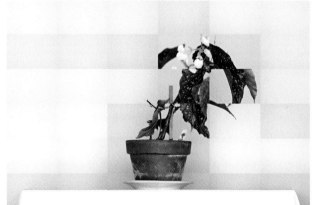

ROY McMAKIN

AMERICAN, BORN 1956

Eight Photographs of an Angel Wing Begonia, 2007.
Chromogenic color prints,
31 ¼ x 43 in. (79.38 x 109.22 cm) each

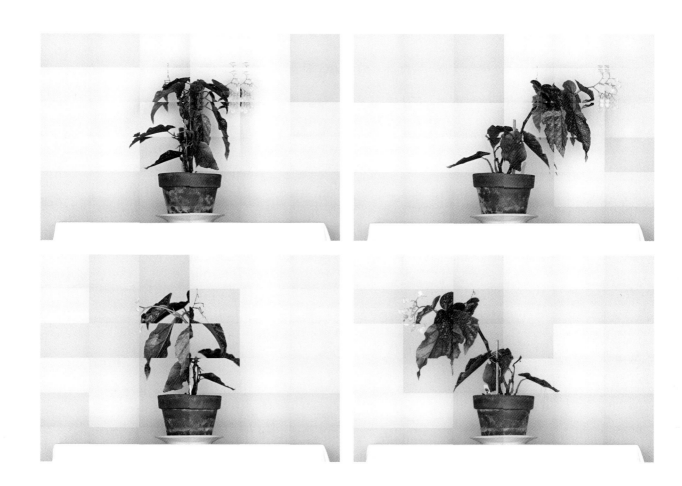

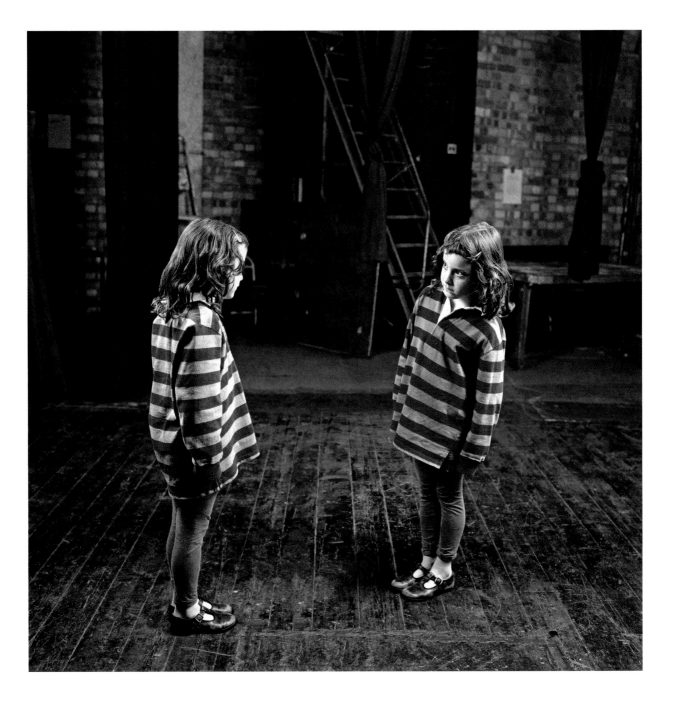

WENDY McMURDO

SCOTTISH, BORN 1962

Helen, Backstage, Merlin Theatre (The Glance), 1995.
Laserchrome print, dimensions variable

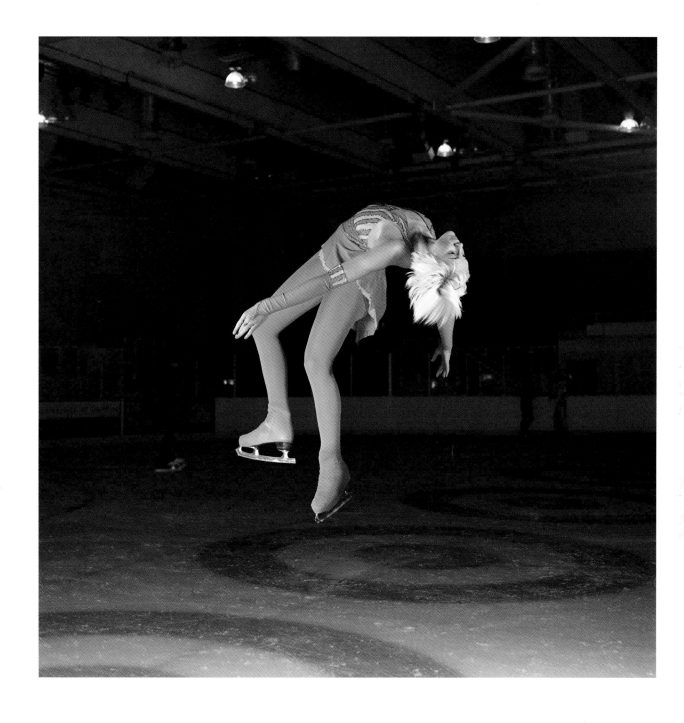

Avatar (i), 2009.
Laserchrome print, dimensions variable

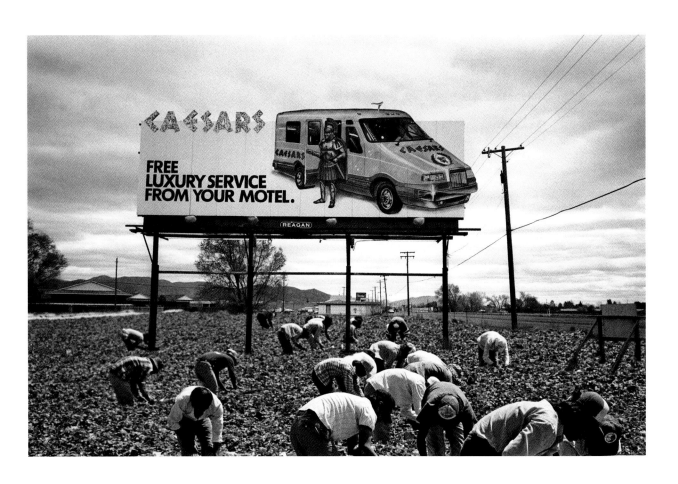

PEDRO MEYER

SPANISH, BORN 1935

Mexican Migrant Workers, California, 1992.
Digitally modified file, dimensions variable

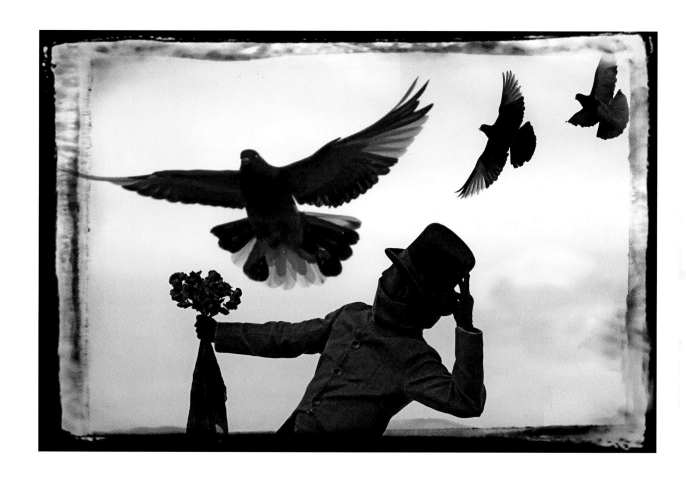

We are all doves, Coyoacan, Mexico, 2004.
Digitally modified file, dimensions variable

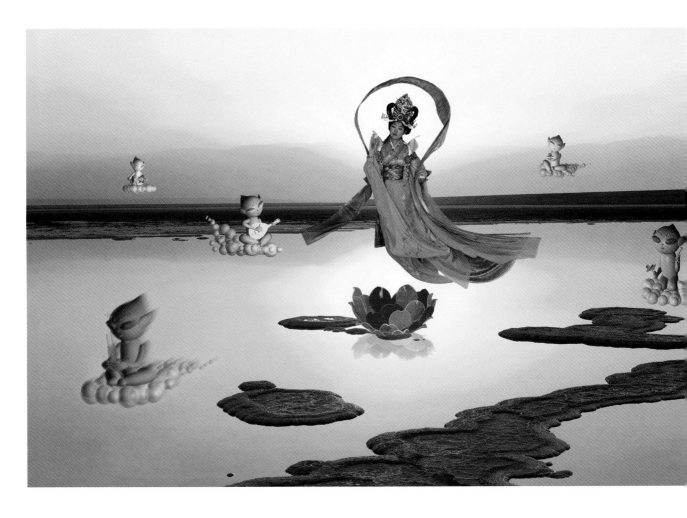

MARIKO MORI

JAPANESE, BORN 1967

Esoteric Cosmos: Pure Land, 1996–98.
Glass with photo interlayer, 120 ⅛ x 240 ⅛ x ⅞ in.
(305 x 610 x 2.2 cm)

(opposite) *Connected World (set I–VI) photopainting II*, 2002.
Prerendered computer graphic content, Lucite frame,
48 in. diameter x 3 in. depth (121.9 x 7.6 cm)

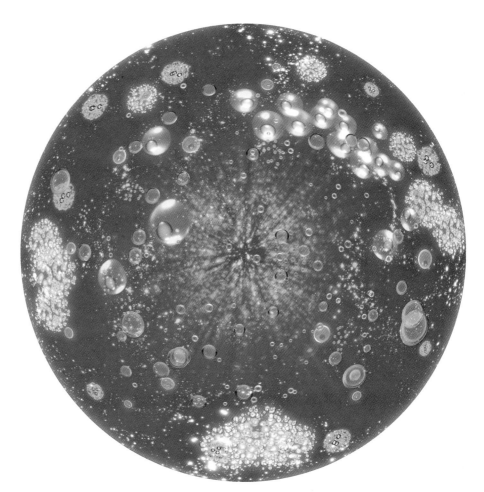

ANDREAS MÜLLER-POHLE
GERMAN, BORN 1951

Digital Scores I (after Nicéphore Niépce), 1995.
Digital pigment print, 26 x 26 in.
(66 x 66 cm)

Spammers' Directory #1, 2005.

Digital pigment print, 31 ½ x 31 ½ in.

(80 x 80 cm)

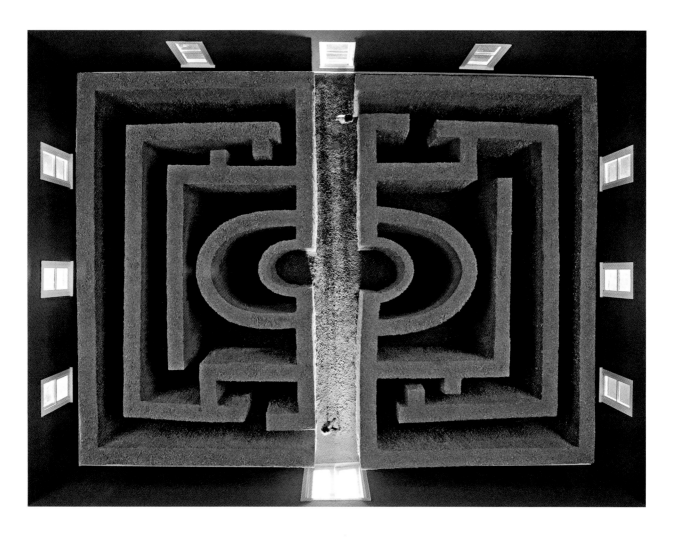

NIC NICOSIA

AMERICAN, BORN 1951

Untitled, #10, 2002.
Archival inkjet print on Somerset watercolor paper,
36 x 48 in. (91.44 x 121.92 cm)

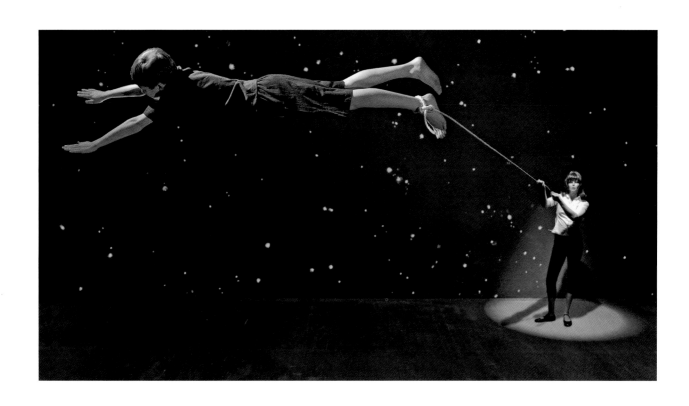

Untitled #2, 2002.
Archival inkjet print on Somerset watercolor paper,
26 ½ x 48 in. (67.31 x 121.92 cm)

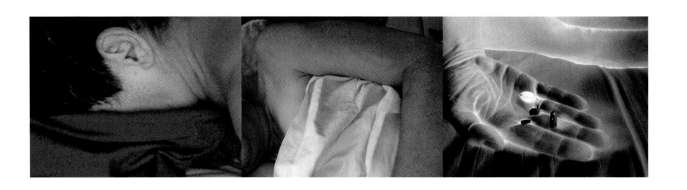

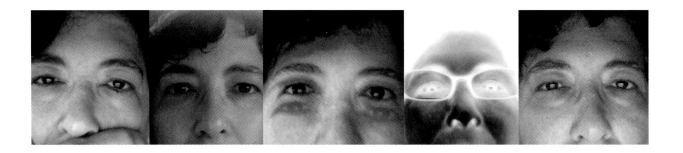

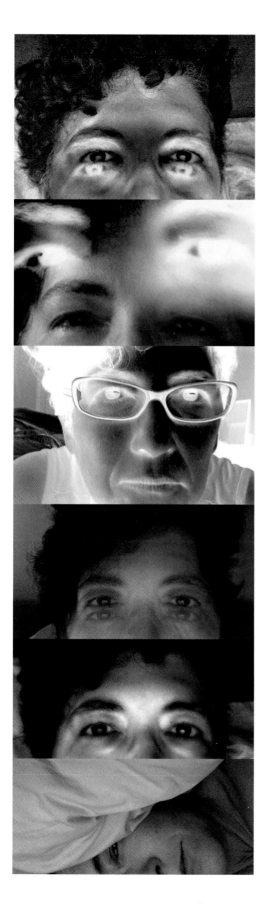

LORIE NOVAK
AMERICAN, BORN 1954

Migraine Register, 2009.
Inkjet prints, dimensions variable;
images made from 640 x 490 px
web-cam photographs

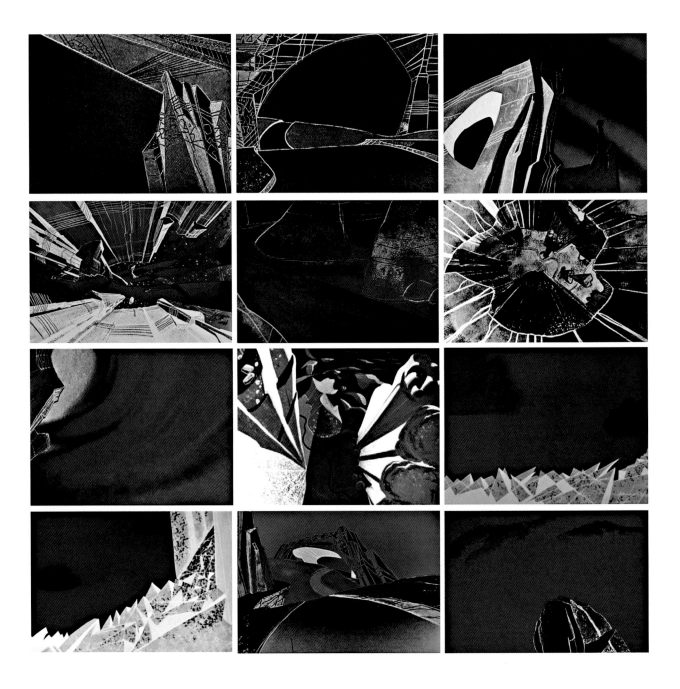

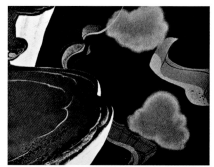

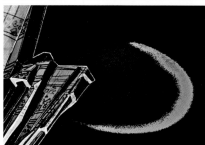

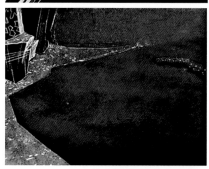

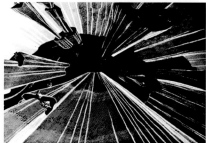

BIRGIT RATHSMANN

GERMAN, BORN 1973

Out West, 2008.
16 chromogenic color prints,
20 x 30 in. (50.8 x 76.2 cm) each

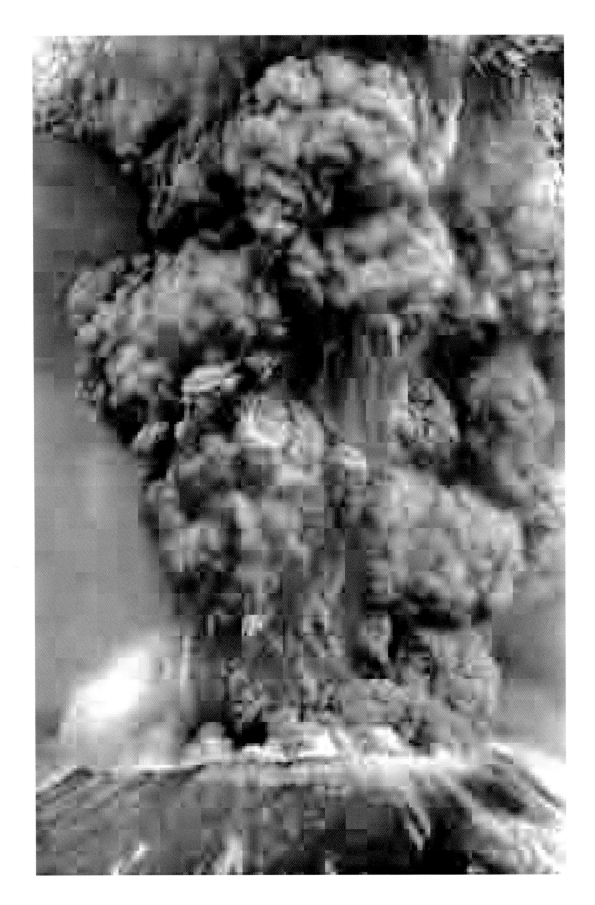

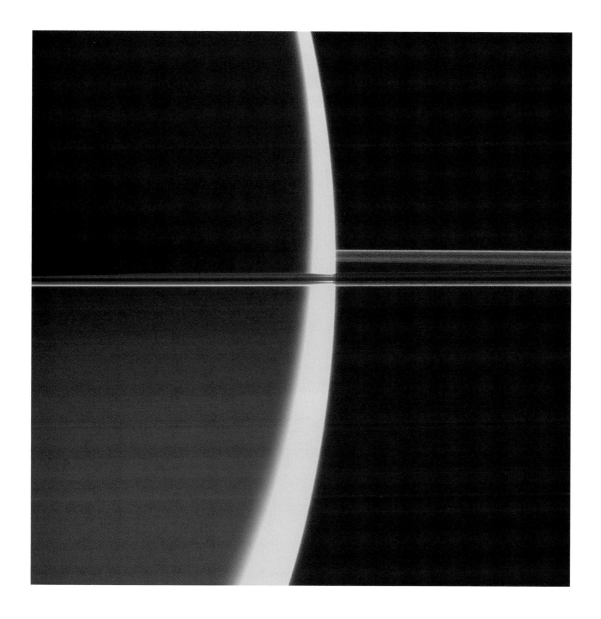

THOMAS RUFF

GERMAN, BORN 1958

Cassini 01, 2008.
Chromogenic color print, 42 ⅝ x 42 ⅝ x 1 ¾ in.
(108.3 x 108.3 x 4.4 cm)

(opposite) *Jpeg msh01*, 2004.
Chromogenic color print with Diasec,
109 x 74 in. (276 x 188 cm)

JASON SALAVON

AMERICAN, BORN 1970

The Top Grossing Film of All Time, 1 x 1, 2000.
Chromogenic color print, 47 x 72 in.
(119.38 x 182.88 cm)

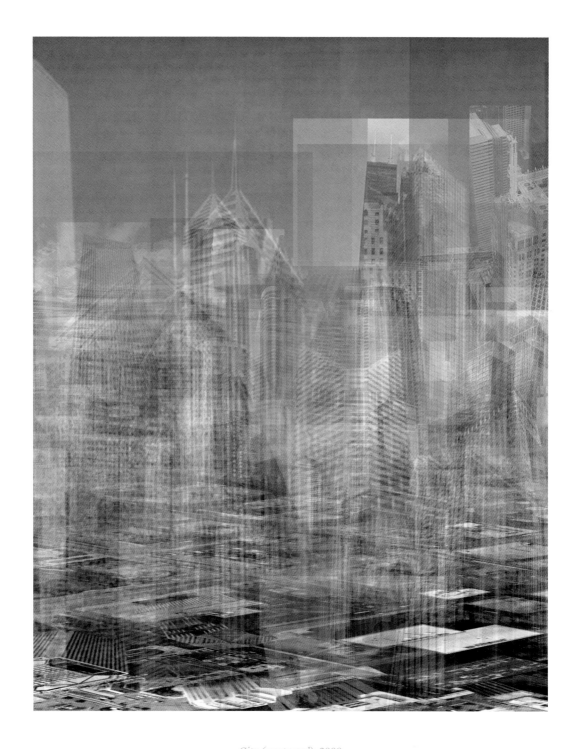

City (westward), 2008.
Chromogenic color print, 60 x 48 in.
(152.4 x 121.92 cm)

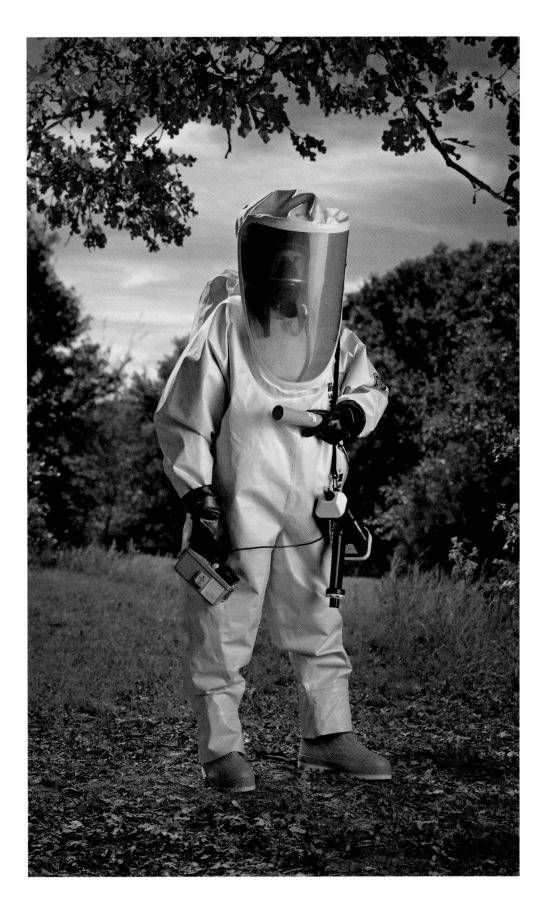

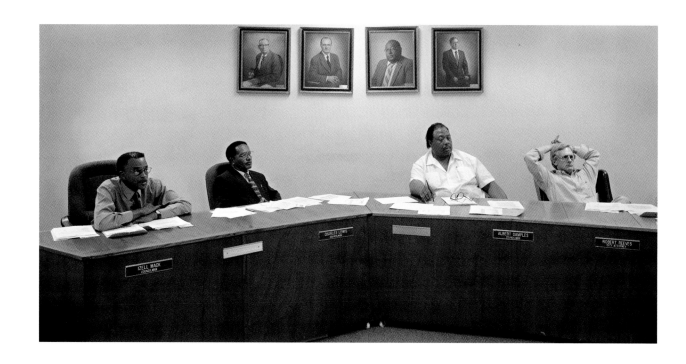

PAUL SHAMBROOM

AMERICAN, BORN 1956

Wadley Georgia (Population 2,468) City Council August 13, 2001
(L to R) Izell Mack, Charles Lewis, Albert Samples (Mayor),
Robert Reeves (City Attorney), 2001. From the series Meetings.
Pigmented inkjet print on canvas with varnish,
33 x 66 in. (83.82 x 167.64 cm)

(opposite) Level A HAZMAT suit, yellow (Disaster City National Emergency Response
and Resume Training Center, Texas Engineering and Extension Service (TEEX),
College Station, TX), 2004. From the series Security.
Pigmented inkjet print on canvas with varnish,
63 x 38 in. (160 x 96.52 cm)

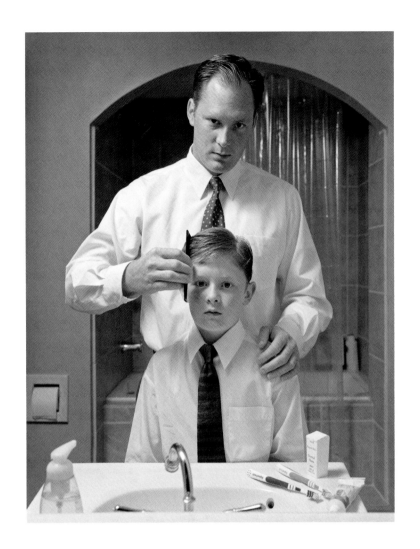

ANGELA STRASSHEIM
AMERICAN, BORN 1969

Untitled (Father and Son), 2004.
From the series *Left Behind*. Chromogenic color print,
40 x 30 in. (101.6 x 76.2 cm)

(opposite) *Evidence No. 2*, 2009.
From the series *Crime*. Archival pigment print,
46 x 58 in. (116.84 x 147.32 cm)

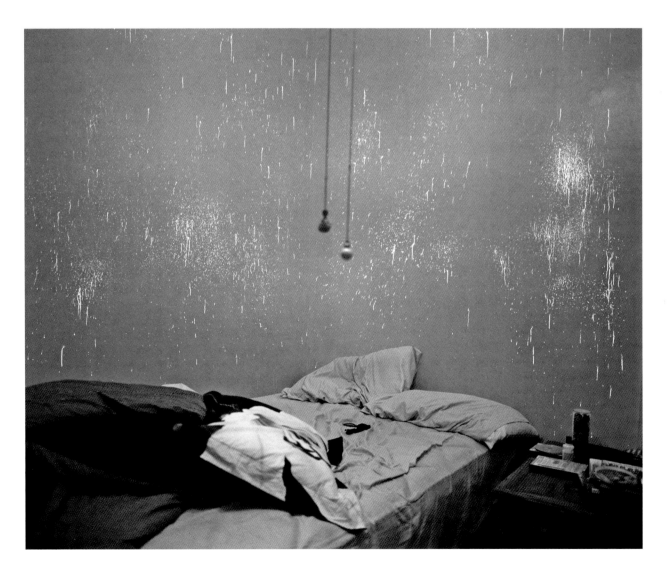

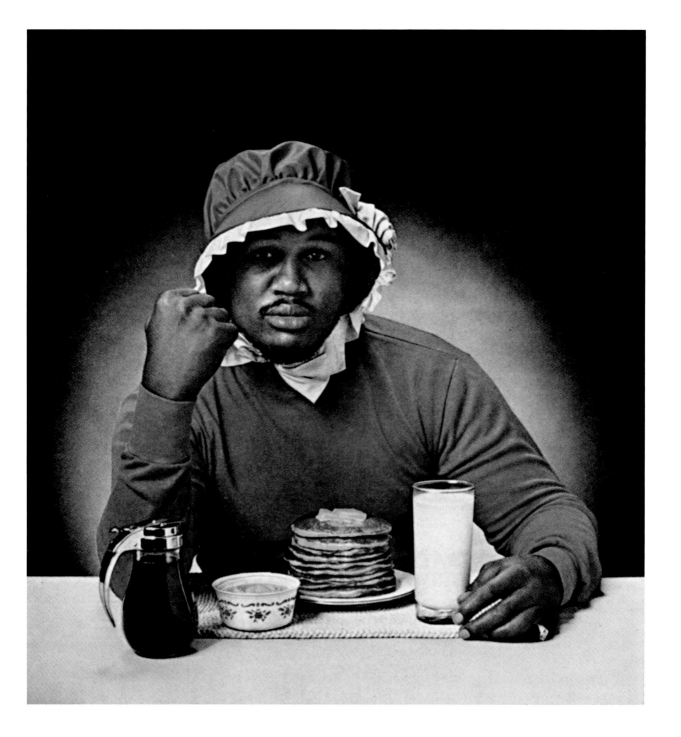

HANK WILLIS THOMAS

AMERICAN, BORN 1976

Smokin' Joe Ain't Jemama. Framed from the series
Unbranded: Reflections in Black by Corporate America, 1978 / 2006.
Lightjet print, dimensions variable

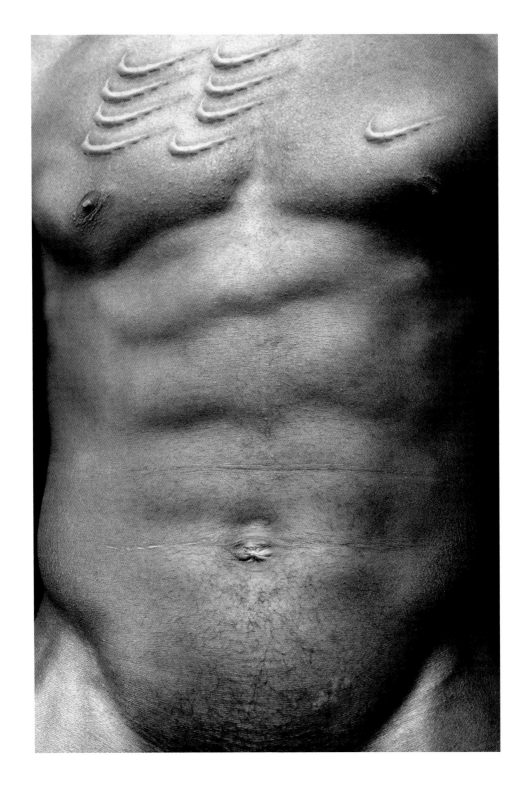

Scarred Chest, 2004. From the series *Branded*.
Lightjet print, dimensions variable

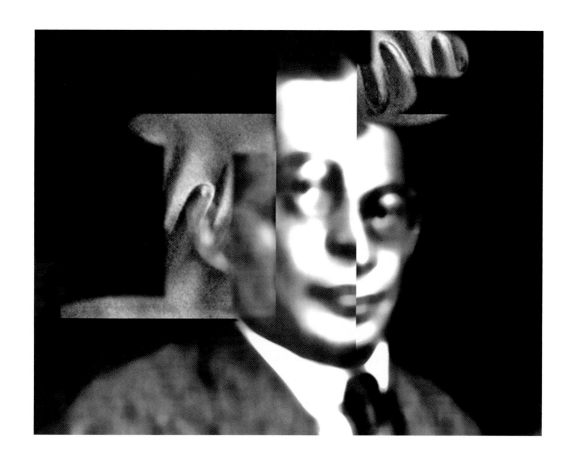

PAUL THOREL
FRENCH, BORN 1956

Otto Rank, 1990.
Digital print, 15 ⅜ x 19 ⅝ in.
(39 x 50 cm)

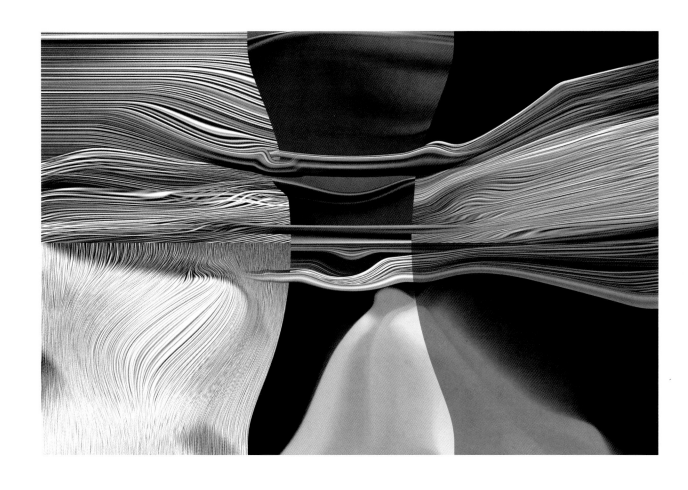

Magma, 2002.
Digital print on alfa cellulose based paper,
26 1/8 x 39 3/8 in. (66.5 x 100 cm)

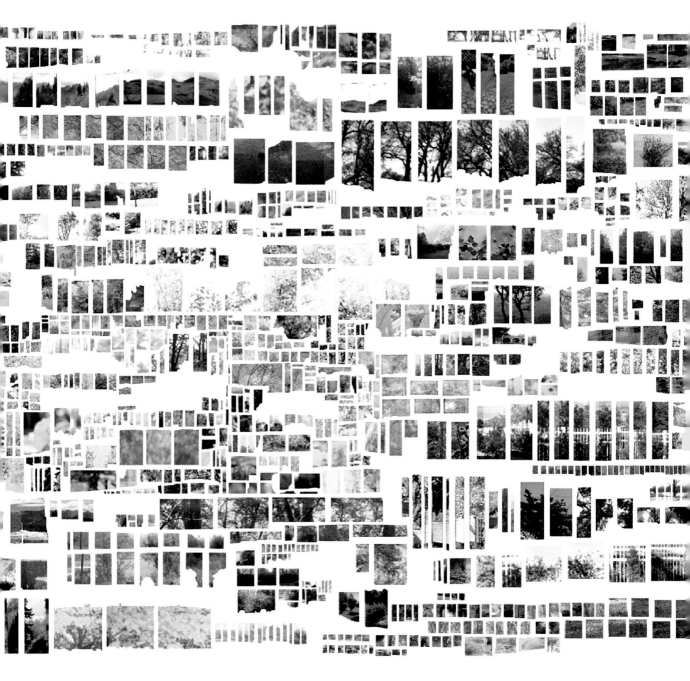

PENELOPE UMBRICO

AMERICAN, BORN 1957

Views From the Internet
(From Home Improvement Websites), 2006–09.
Individually cut inkjet prints,
dimensions variable

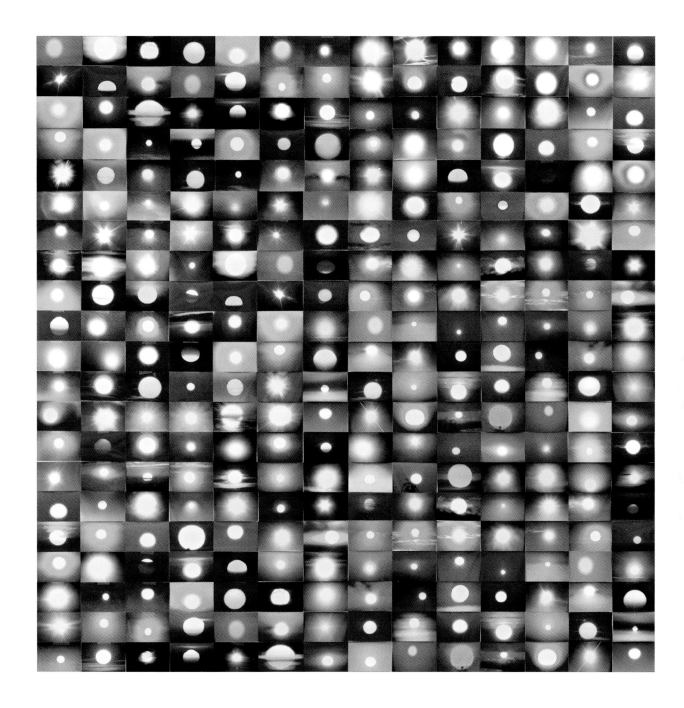

6,206,044 Suns from Flickr (Partial) 10/25/09, 2007–09.
Detail of 2,000 Kodak machine chromogenic
color prints, 4 x 6 in. (10.2 x 15.2 cm) each;
installation dimensions variable

SIEBREN VERSTEEG

AMERICAN, BORN 19XX

100 Years of Google Images, 2007.
Pigmented inkjet print
mounted to aluminum, 22 ⅝ x 51 ⅛ in.
(57.5 x 129.9 cm)

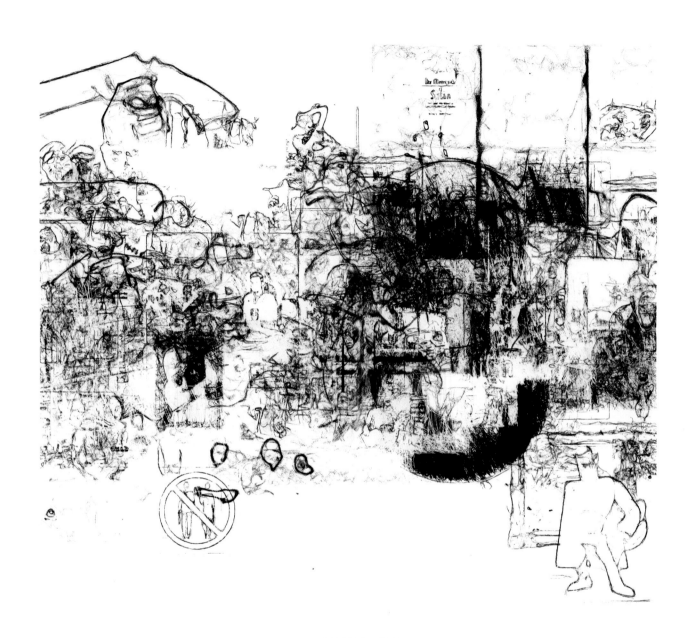

satan_522249.jpg, 2007.
Pigmented inkjet print, 15 ½ x 17 ½ in.
(39.4 x 44.5 cm)

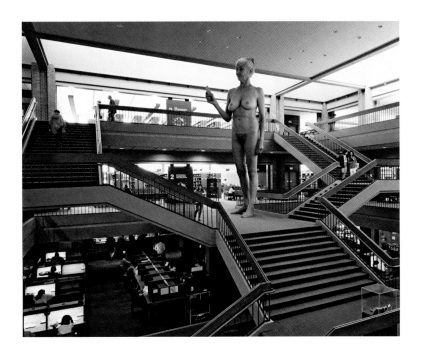

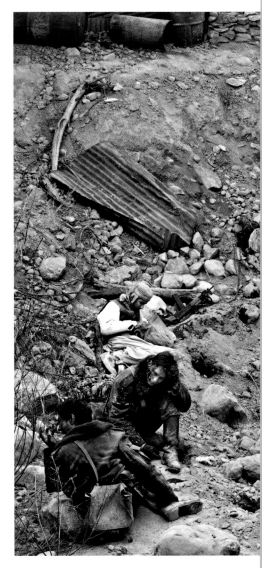

JEFF WALL
CANADIAN, BORN 1946

The Giant, 1992.
Transparency in lightbox, 15 ⅜ x 18 ⅞ in.
(39 x 48 cm)

(opposite) *Dead Troops Talk (a vision
after an ambush of a Red Army Patrol, near
Moquor, Afghanistan, winter 1986)*, 1992.
Transparency in lightbox, 90 ³⁄₁₆ x 164 ³⁄₁₆ in.
(229 x 417 cm)

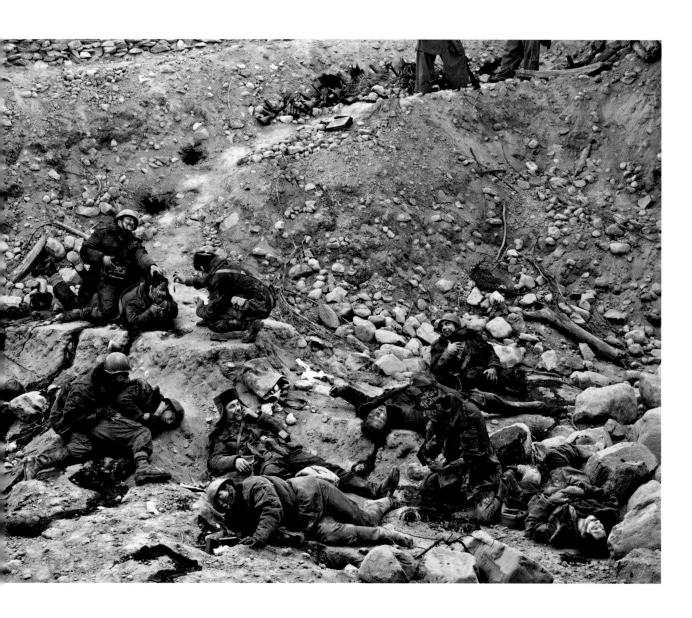

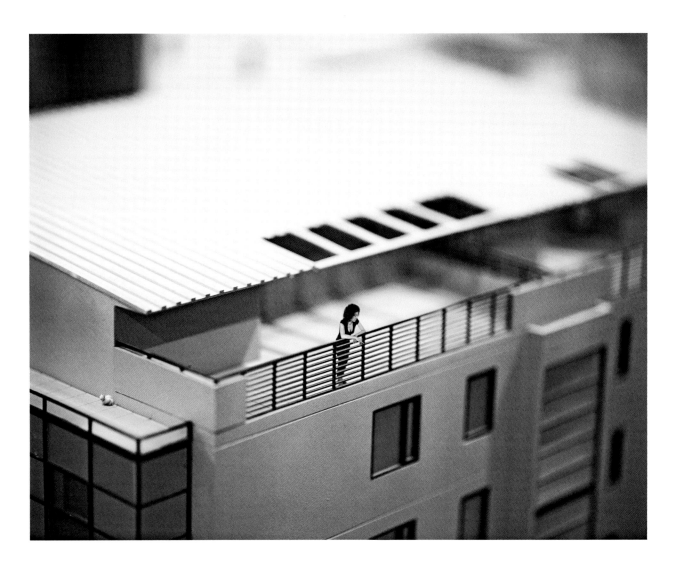

XING DANWEN

Urban Fiction, Image 9, 2004.
Chromogenic color print, 67 x 84 in.
(170 x 213.2 cm)

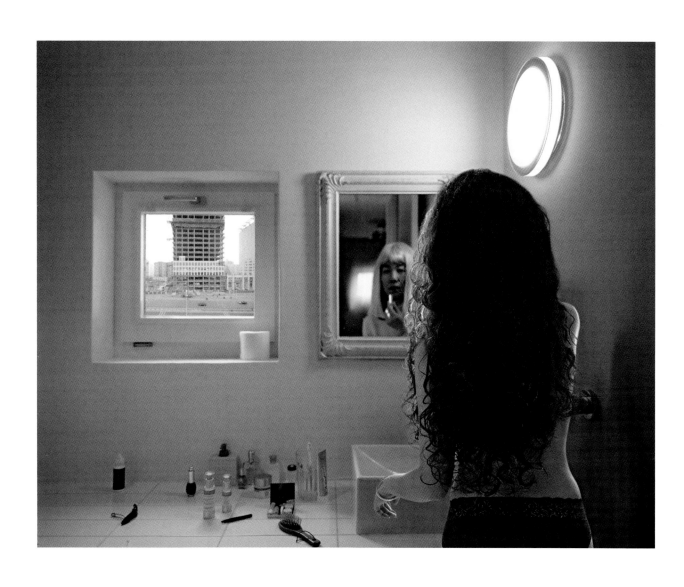

Wall House, Image 2, 2007.
Chromogenic color print or photo lightbox,
31 ½ x 39 ½ in. (80 x 100 cm)

AMIR ZAKI

AMERICAN, BORN 19XX

Artwork #1, 2007.
Ultrachrome archival photograph, 45 x 56 in.
(114.3 x 142.24 cm)

(opposite) *Untitled (Tower 42)*, 2009.
Ultrachrome archival photograph, 61 x 77 in.
(154.94 x 195.58 cm)

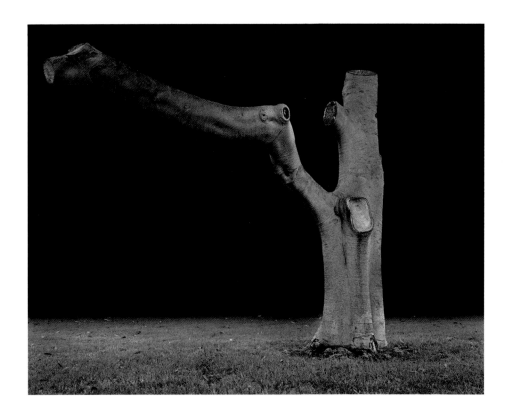

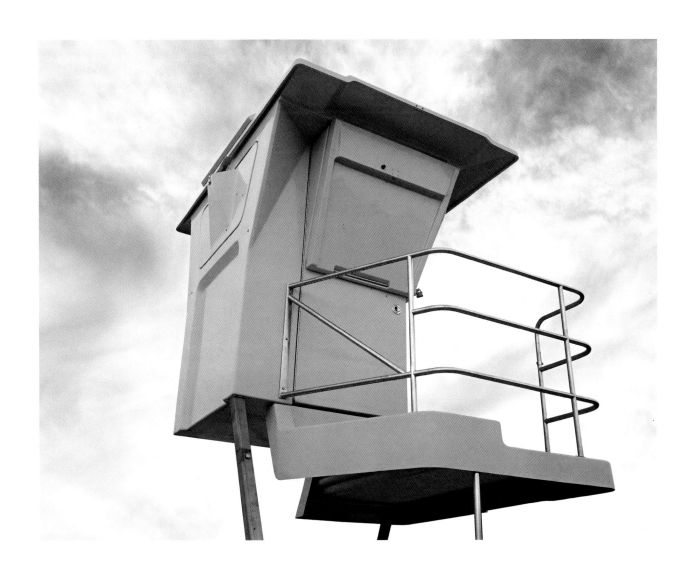

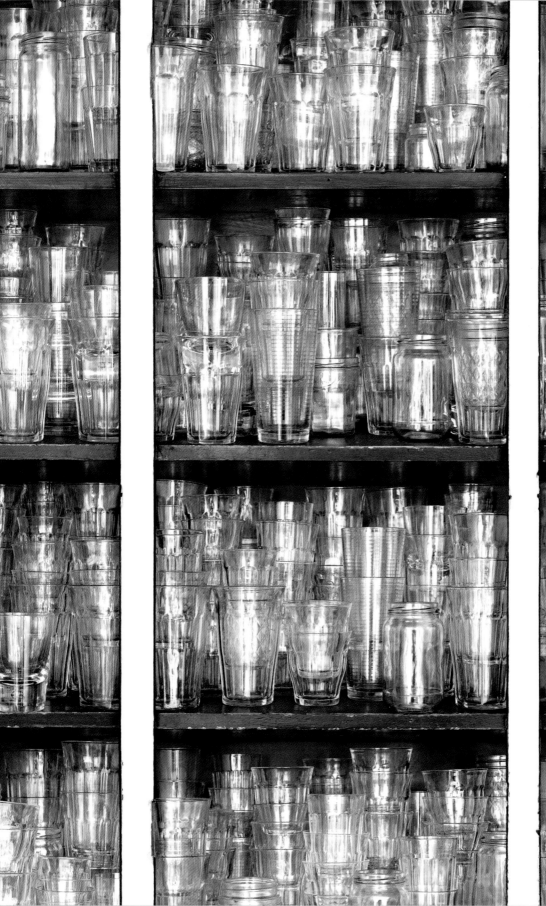

Acknowledgments

This book arose out of a desire to try to understand new imaging technologies as they affect the art of photography at this point in the medium's history. In selecting artists for this project, I looked for those whose work was inspired, informed, or facilitated by digital technology. In some cases, the work would not have been possible without digital intervention. In other cases, the ideas for the work itself are rooted in computer technology.

I am deeply indebted to Christopher Lyon and Curt Holtz at Prestel Publishing for enthusiastically embracing this project from the beginning, for their commitment to artistic excellence, and for editing this book with intelligence, insight, and rigor. The book's production was deftly guided by Reegan Köster and Ryan Newbanks. For the handsome design of this publication, I extend sincere appreciation to Mark Melnick. Lisa Tanzosh is gratefully acknowledged for creating a useful index. I owe a special debt of gratitude to Gina Glascock-Broze, who secured reproduction rights for this book and provided invaluable support and good cheer throughout.

In researching this subject, I benefited immeasurably from those who have previously written on digital photography, especially those listed in a selected bibliography at the back of this book. I am particularly grateful to Fred Ritchin, who introduced me to the many issues inherent in the digital revolution with his seminal 1999 publication *In Our Own Image*, and who fielded queries for this book. A special debt of gratitude is extended to Paul Berger for sharing his understanding of digital imaging technologies and his insight into their impact on visual experience.

Many colleagues and friends shared their thoughts and pointed me to artists of interest for this project. For their support, I wish to thank Susan Meiselas, Lorie Novak, Christopher Phillips, Hank Willis Thomas, David Travis, and Deborah Willis. Thanks go as well to the staff of the Henry Art Gallery with whom I consulted during the research of this book, in particular Elizabeth

Brown, Chief Curator, and Sara Krajewski, Associate Curator. I would also like to thank Duane Schuler, for providing invaluable support and serving as a crucial sounding board throughout this project.

Numerous individuals at galleries, archives, artist studios, and estates offered assistance by responding to queries and requests for reproduction with speed and generosity. Finally, I am deeply indebted to the artists in this book for the work that spurred my inquiry. Conversations and correspondences with many of them during my research were a privilege and a pleasure. By entering into a discussion about digital photography with them and through this publication, I hope to provide a snapshot of digital photographic art for today's audiences and initiate future dialogue and debate.

SYLVIA WOLF

Selected_Bibliography

Crary, Jonathan. *Techniques of the Observer: On Vision and Modernity in the Nineteenth Century*. Cambridge, Mass.: MIT Press, 1990.

De Roquette, Ysabel (ed.). *Art/Photographie Numerique*. Aix-en-Provence: Cyprès, 1995.

Druckrey, Timothy (ed.). *Iterations: The New Image*. Cambridge, Mass.: MIT Press, 1993.

Haworth-Booth, Mark. *Metamorphoses: Photography in the Electronic Age*. New York: Aperture, 1994.

Lipkin, Jonathan. *Photography Reborn: Image Making in the Digital Era*. New York: Harry N. Abrams, 2005.

Manovich, Lev. *The Language of New Media*. Cambridge, Mass.: MIT Press, 2002.

Mitchell, William J. *The Reconfigured Eye: Visual Truth in the Post-Photographic Era*. Cambridge, Mass.: MIT Press, 1992.

Paul, Christiane. *Digital Art*. London: Thames & Hudson, 2003.

Ritchin, Fred. *After Photography*. New York: Norton, 2009.

Ritchin, Fred. *In Our Own Image: The Coming Revolution in Photography*. New York: Aperture, 1999.

Rush, Michael. *New Media in Late 20th-Century Art*. London: Thames & Hudson, 1999.

Traub, Charles H., and Jonathan Lipkin. *In the Realm of the Circuit: Computers, Art, and Culture*. Upper Saddle River, N.J.: Pearson Prentice Hall, 2004.

Von Amelunxen, Hubertus, Stefan Iglhaut, and Florian Rötzer, and Alexis Cassel. *Photography after Photography: Memory and Representation in the Digital Age*. Newark: G+B Arts, 1996.

Wands, Bruce. *Art of the Digital Age*. New York: Thames & Hudson, 2006.

Wardrip-Fruin, Noah and Nick Montfort (eds.). *The New Media Reader*. Cambridge, Mass.: MIT Press, 2003.

Index

Image_Credits

pp. 56, 57: © Alexander Apostol; courtesy of the artist | p. 39: © Ida Applebroog; courtesy of the artist | pp. 10–11, pp. 58, 59: © Aziz + Cucher; courtesy of the artists | pp. 26–27: © Tom Bamberger; courtesy of the artist and Leslie Tonkonow Art Work + Projects | pp. 42, 60–61: © Paul Berger; courtesy of the artist | pp. 62, 63: © Julie Blackmon; courtesy of the artist and G. Gibson Gallery, Seattle | pp. 65, 65: © Shelia Pree Bright; courtesy of the artist | p. 50: © Victor Burgin; courtesy of the artist | pp. 66, 67: © Nancy Burson; courtesy of ClampArt, New York | pp. 68, 69: © Peter Campus; courtesy of the artist | pp. 16–17, 70–71, endpapers: © Daniel Canogar; courtesy of the artist | pp. 72–73: © Helen Chadwick Estate; digital image © Leeds Museum and Galleries, Henry Moore Institute | pp. 74, 75: © Keith Cottingham; courtesy of Ronald Feldman Fine Arts | pp. 20–21, 76, 77: © Sean Dack; courtesy of the artist and Daniel Reich Gallery | pp. 78, 79: © Joan Fontcuberta; courtesy of the artist | pp. 80–81: © Tom Friedman; courtesy of Gagosian Gallery | pp. 82, 83: © Noriko Furunishi; courtesy of Murray Guy Gallery | pp. 84, 85: © Margie Geerlinks; courtesy of the artist | pp. 86, 87: © Ben Gest; courtesy of the artist | pp. 8–9, 88, 89: © Luis Gispert; courtesy of the artist | pp. 90–91: © Anthony Goicolea; courtesy of the artist | pp. 92, 93: © Andreas Gursky, licensed by Monika Sprüth / Philomene Magers / VG Bild-Kunst, Bonn 2009; courtesy of Matthew Marks Gallery | pp. 18–19, 94, 95: © Jon Haddock; courtesy of the artist and Howard House Contemporary | pp. 96–97: © Dieter Huber; courtesy of www.dieter-huber.com | pp. 98–99: © Simen Johan; courtesy of Yossi Milo Gallery, New York | pp. 12–13, 35: © Chris Jordan; courtesy of the artist | pp. 100, 101: © Craig Kalpakjian; courtesy of the artist | pp. 102, 103: © Roshini Kempadoo; courtesy of the artist | pp. 104, 105: © Idris Khan; courtesy of Fraenkel Gallery, San Francisco and Victoria Miro Gallery, London | pp. 106, 107: © Brandon Lattu; courtesy of the artist and Leo Koenig, Inc., New York | pp. 108, 109, 168: © Isaac Layman; courtesy of the artist | pp. 110–11: © Sherrie Levine; courtesy of the artist and the Paula Cooper Gallery, New York | pp. 112–13: © Martina Lopez; courtesy of the artist | pp. 114, 115: © Loretta Lux, VG Bild-Kunst, Bonn 2009; courtesy of Yossi Milo Gallery, New York | pp. 116, 117: © Florian Maier-Aichen; courtesy of the artist, Blum & Poe, Los Angeles, 303 Gallery, New York, and Gagosian Gallery, London | pp. 118–19: © Iñigo Manglano-Ovalle; courtesy of the artist and Max Protetch Gallery | pp. 120, 121: © MANUAL; courtesy of the artists | pp.

Restart . . .

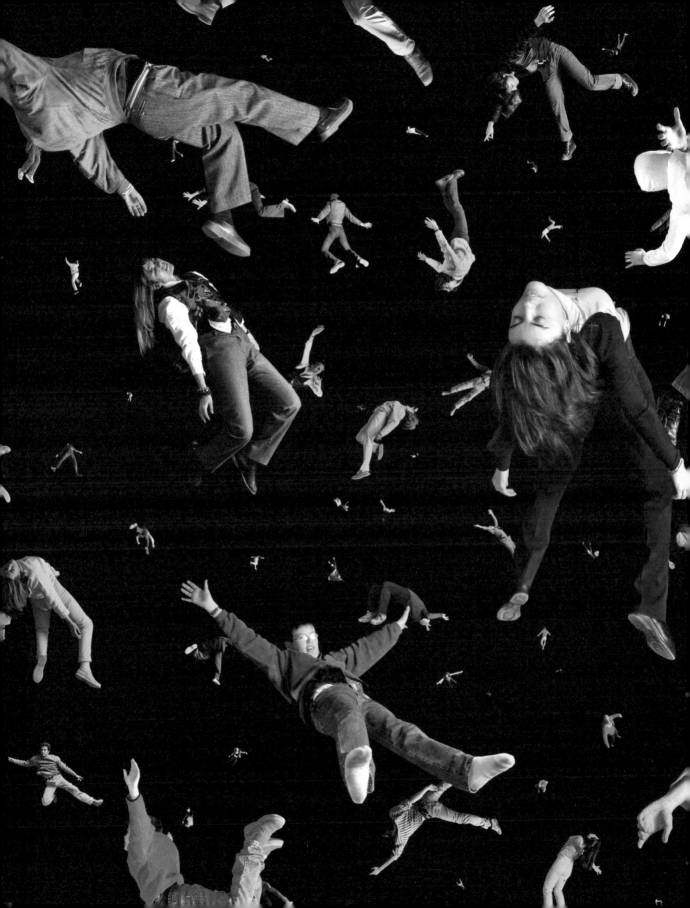

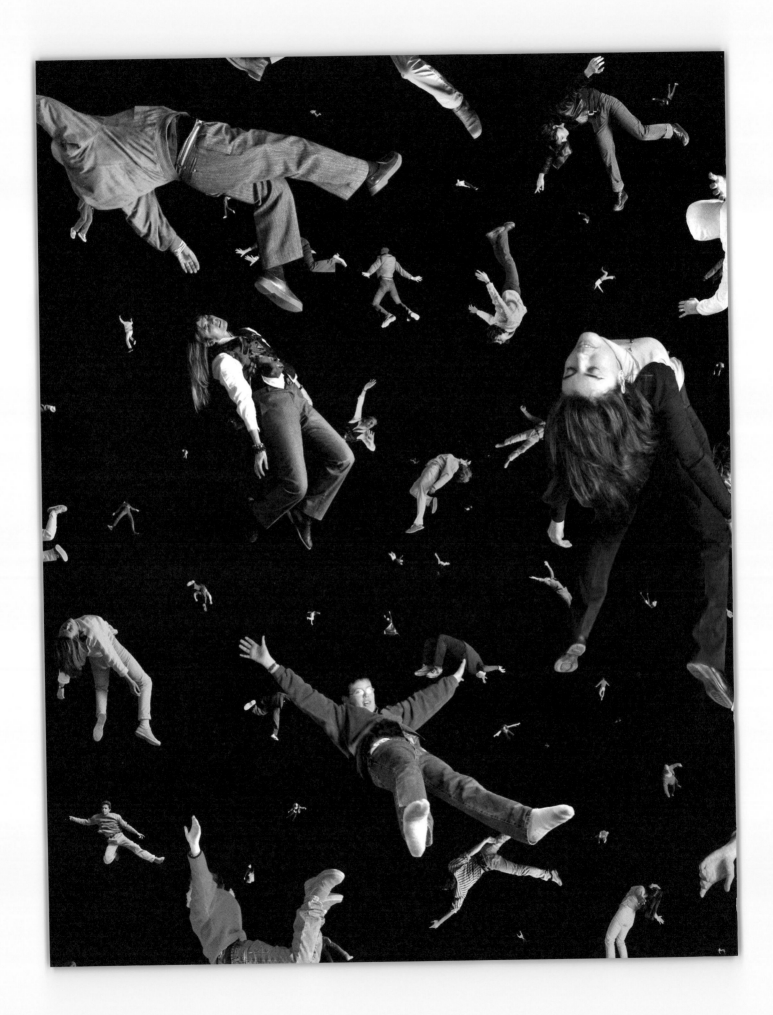